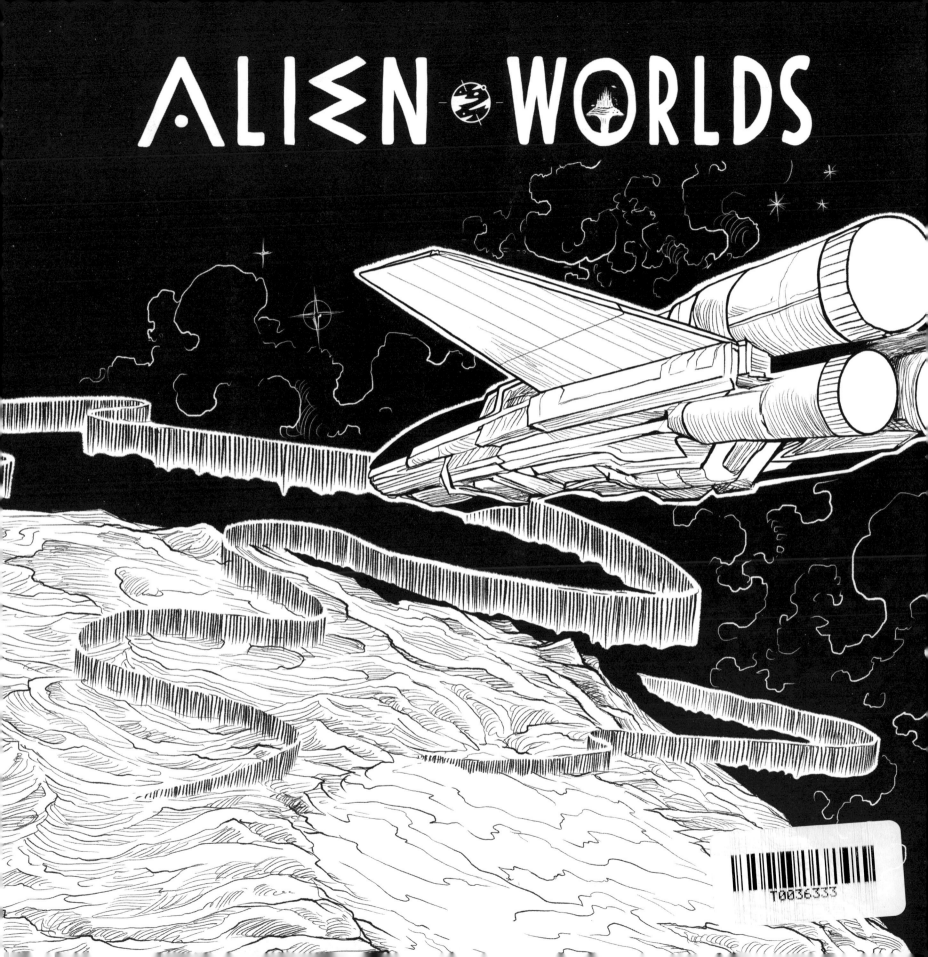

ALIEN WORLDS

ILLUSTRATED BY
KERBY ROSANES

THIS BOOK BELONGS TO:

..

EDITED BY JONNY LEIGHTON
DESIGNED BY DERRIAN BRADDER AND JADE MOORE
COVER DESIGN BY JOHN BIGWOOD

WITH THANKS TO HARRY THORNTON
FOR BEING A GREAT TALENT SCOUT

PLUME
An imprint of Penguin Random House LLC
penguinrandomhouse.com

W www.mombooks.com/lom
f Michael O'Mara Books
𝕏 OmaraBooks
◎ lomart.books

Plume is a registered trademark and
its colophon is a trademark of
Penguin Random House LLC

ISBN: 9780593472101 (paperback)

Printed in the
United States of America
1st Printing

DISCOVER DISTANT ALIEN WORLDS IN THIS COLORING EXPLORATION.

Take an interstellar voyage to my high-definition, superdetailed worlds, where you'll encounter the most incredible alien creatures in the cosmos.

Each intricate illustration has been crafted with fineliner pens and can be colored in any way you like.

For the fascinating stories behind each of these unique worlds and their inhabitants, turn to the astronaut's log at the back of the book.

Kerby Rosanes

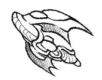
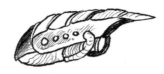
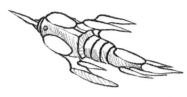

CONTENTS

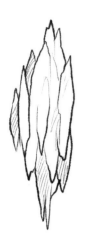

THE LOST PARADISE
An unspoiled utopia with wondrous creatures and lush landscapes. 8

THE FLOATING WORLD
A gas planet with floating islands and incredible flying life-forms. 16

THE WATER REALM
A water world where monstrous predators lurk in the deep. 24

THE FUTURISTIC PLANET
An artificial marvel with advanced cities and high-tech aliens. 32

THE ROCKY BARRENS
A stunning rocky landscape with hardy creatures and underground citadels. 40

THE HEAVENLY INFERNO
A scorched world covered in lava flows and fire-breathing beasts.

48

THE CRYSTAL KINGDOM
A glittering sphere of bejeweled creatures and crystal castles.

56

THE FROZEN WASTES
An icy world with burrowing species and alien hunters.

64

THE STEAMPUNK SPHERE
A mechanical world filled with sentient, steam-powered automata.

72

THE DESOLATE RUIN
An abandoned planet where new life thrives in the ruins of an old civilization.

80

THE ASTRONAUT'S LOG
A journal of all the magnificent creatures found by the lone astronaut.

88

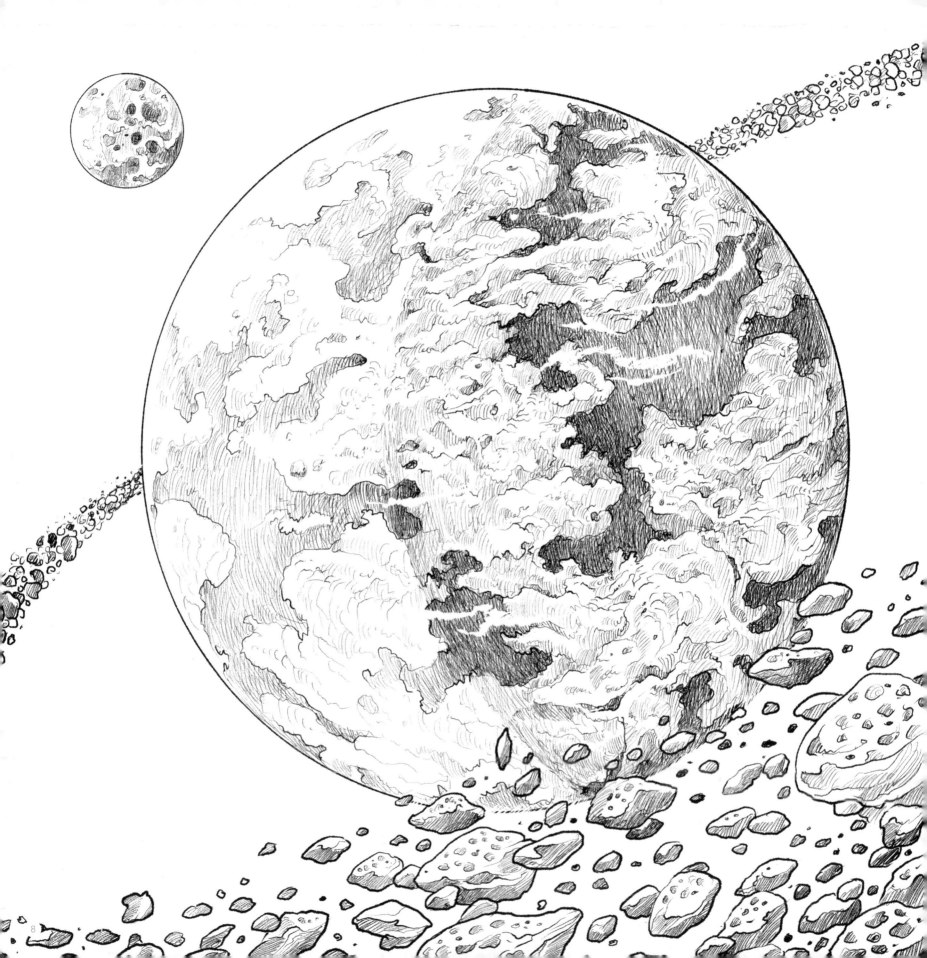

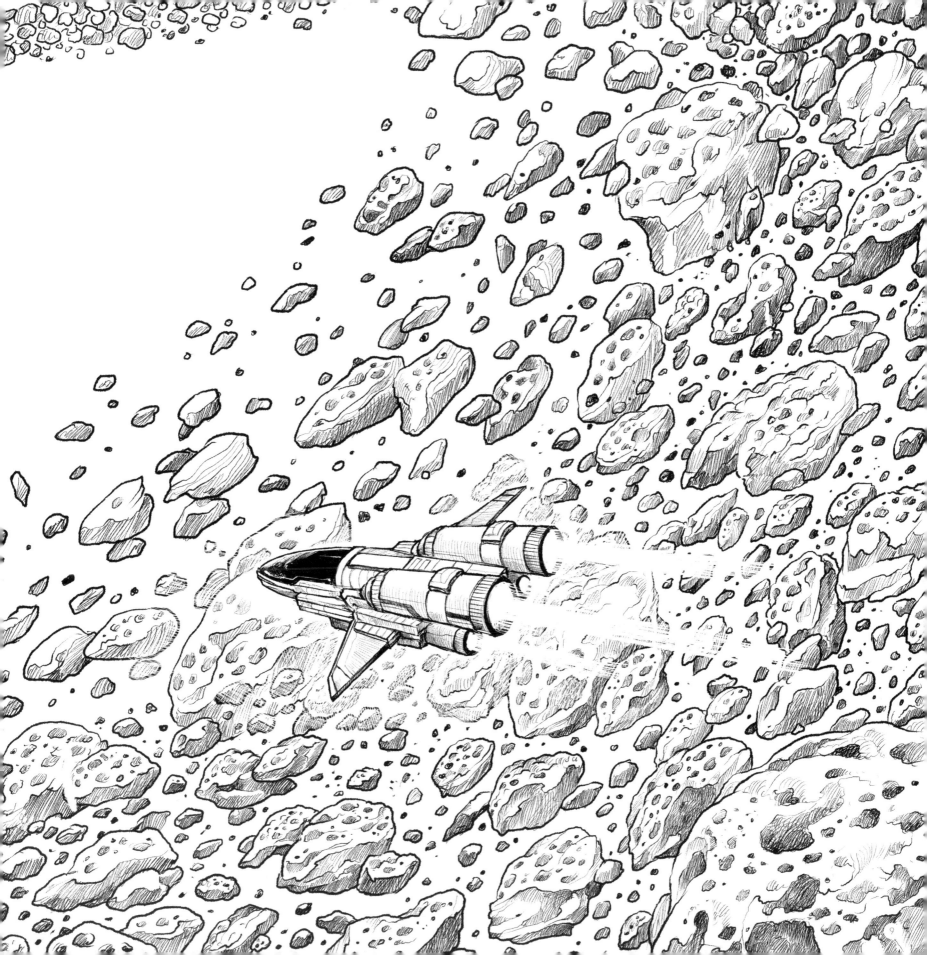

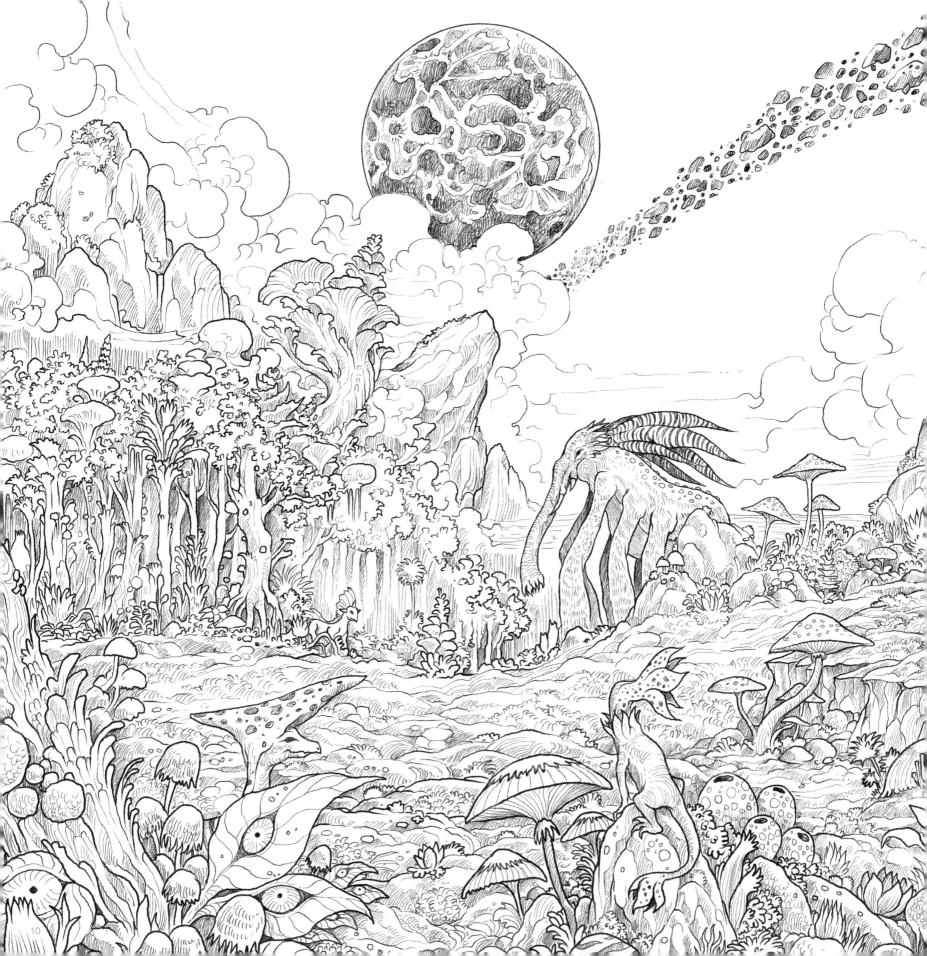

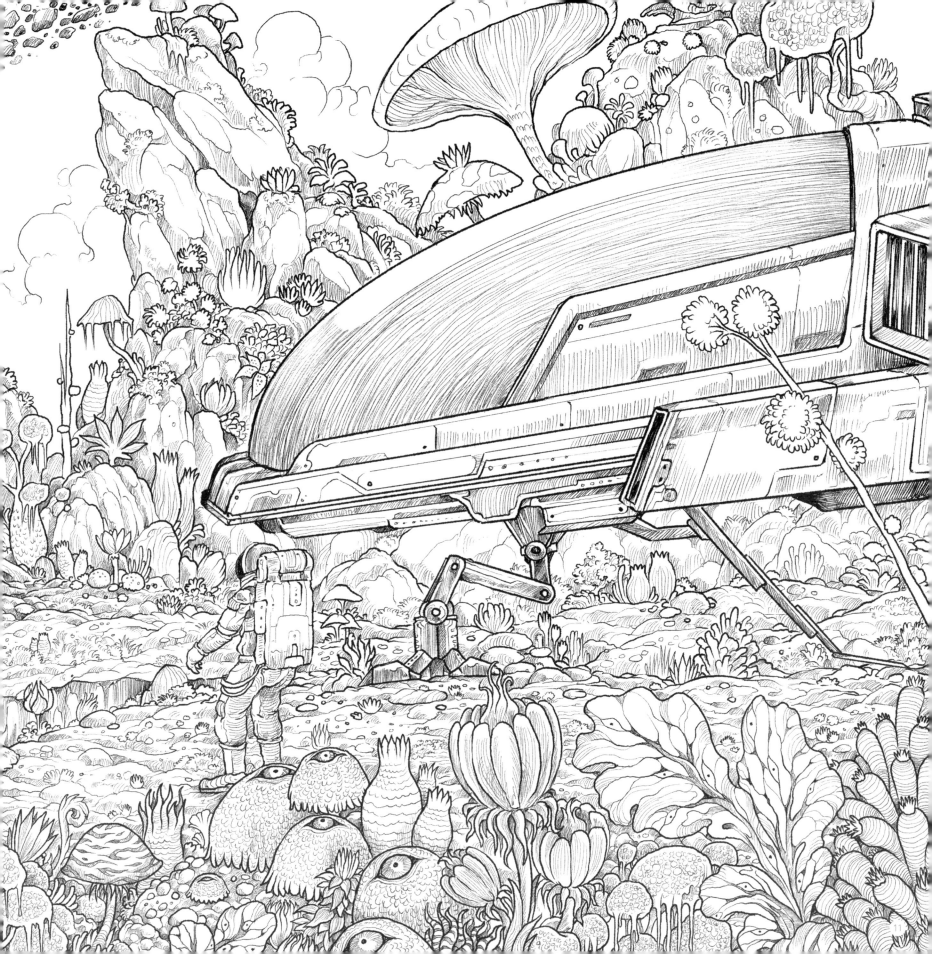

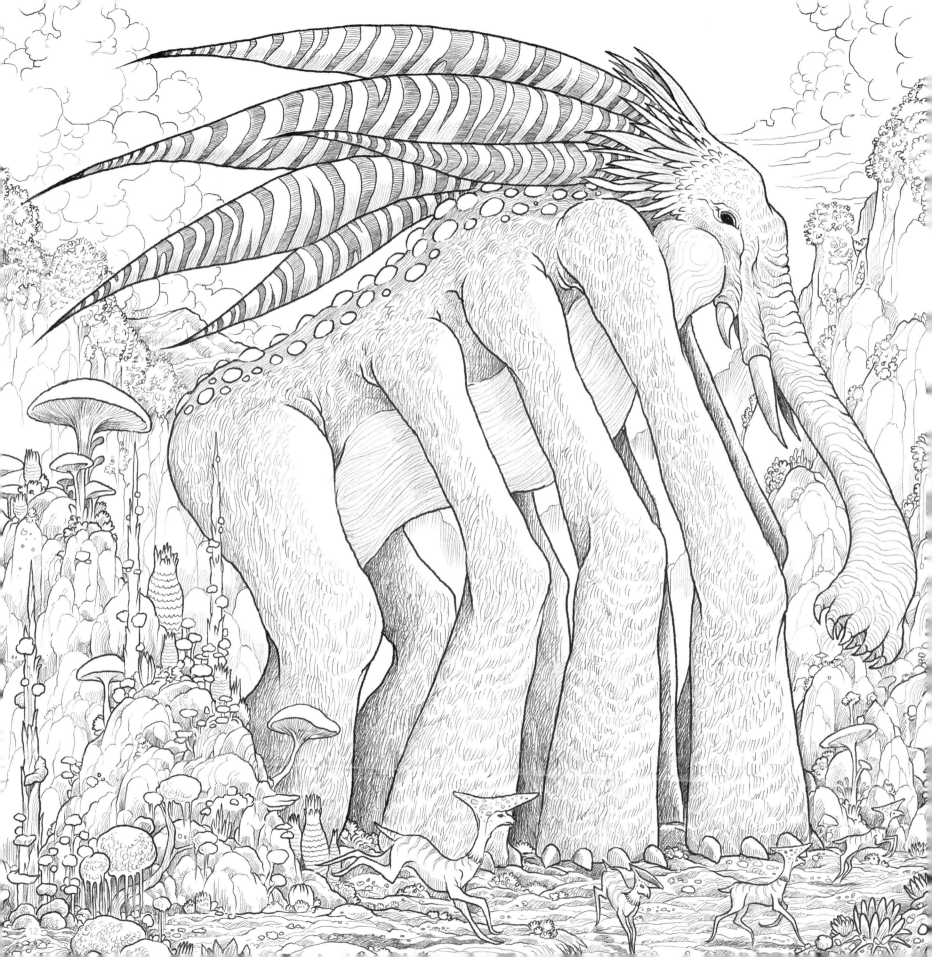

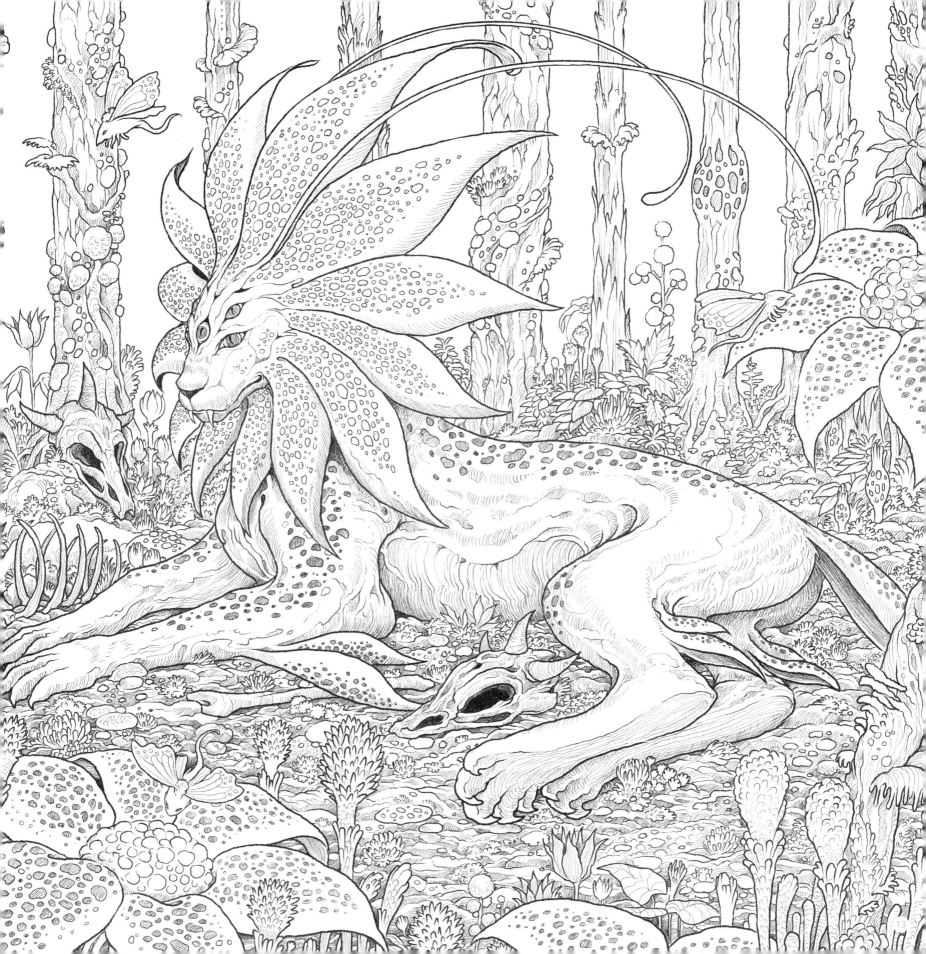

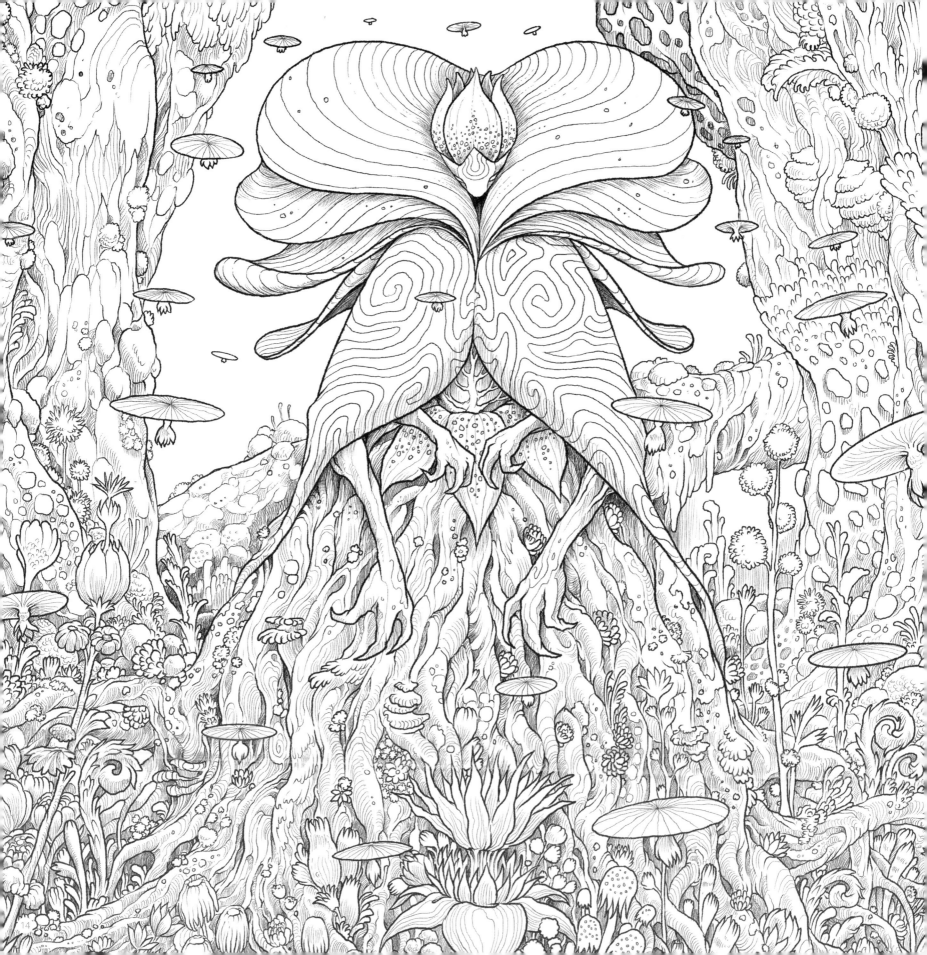

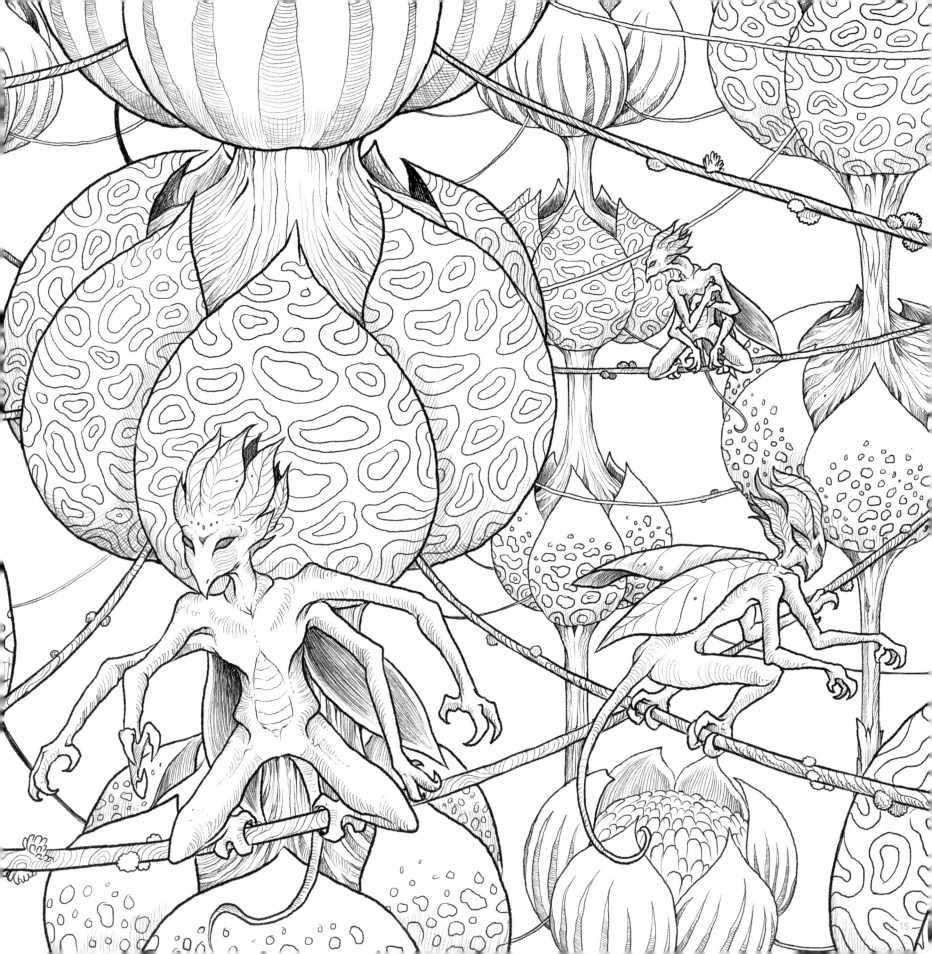

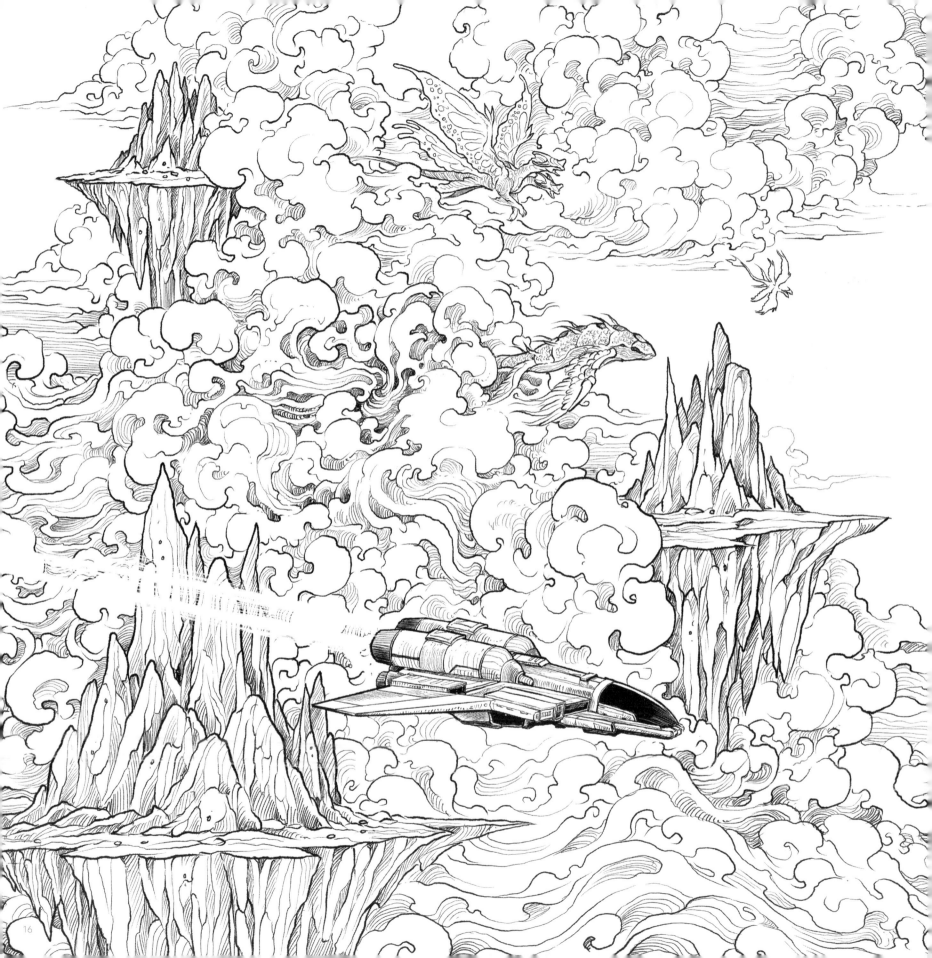

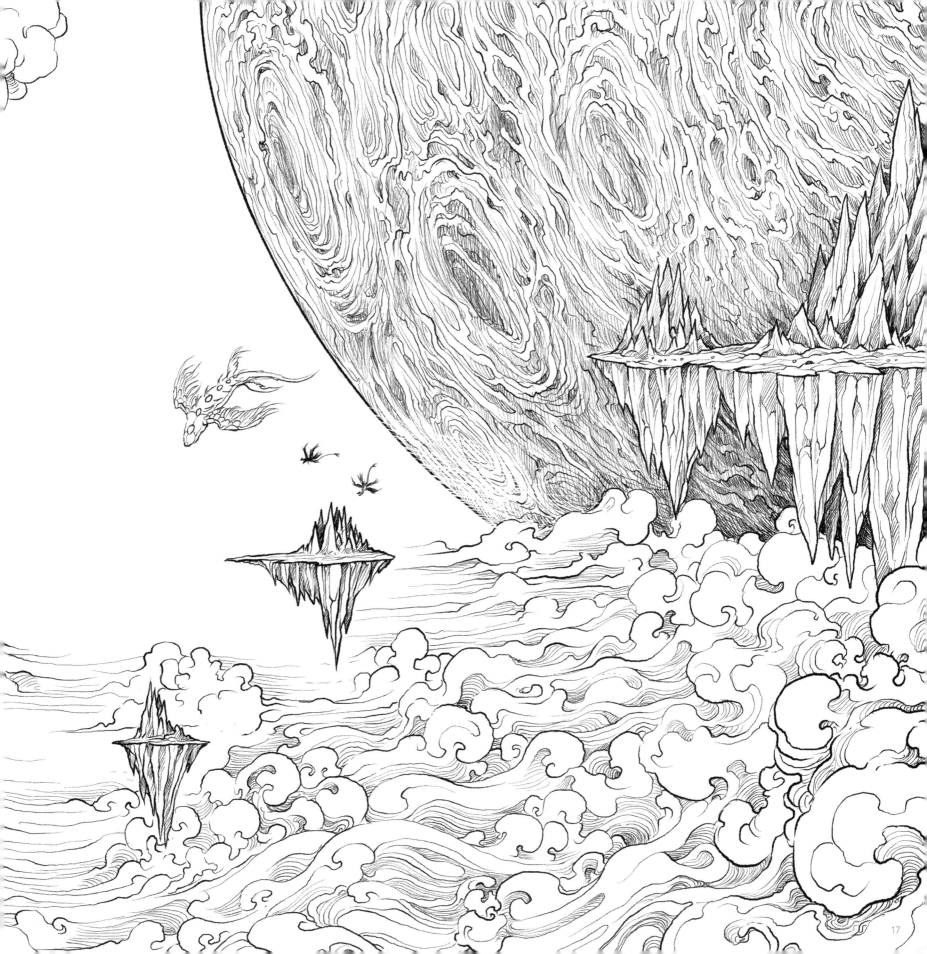

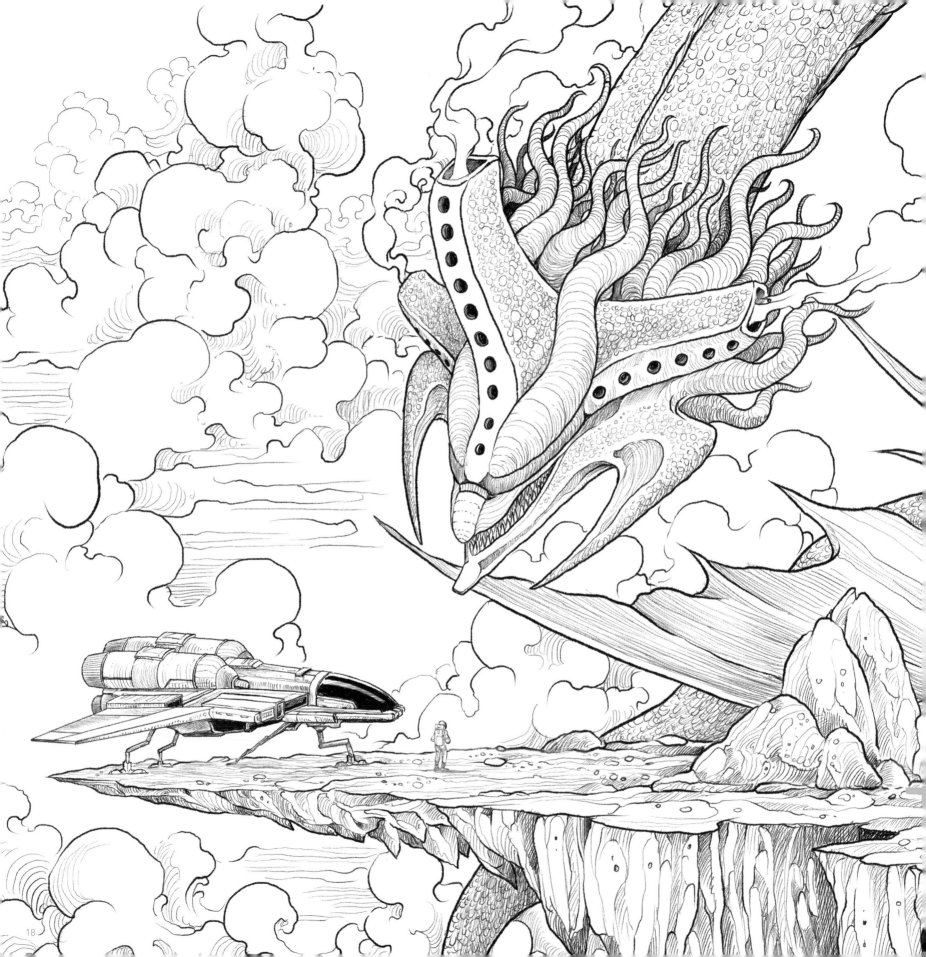

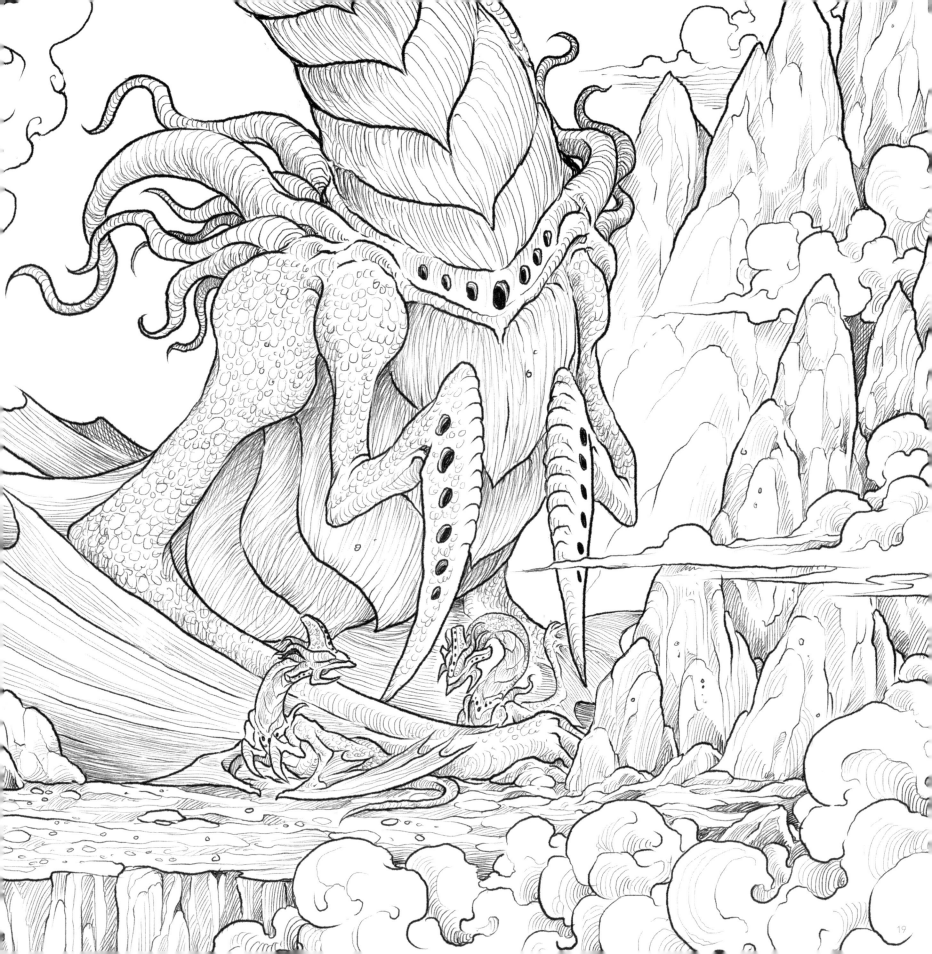

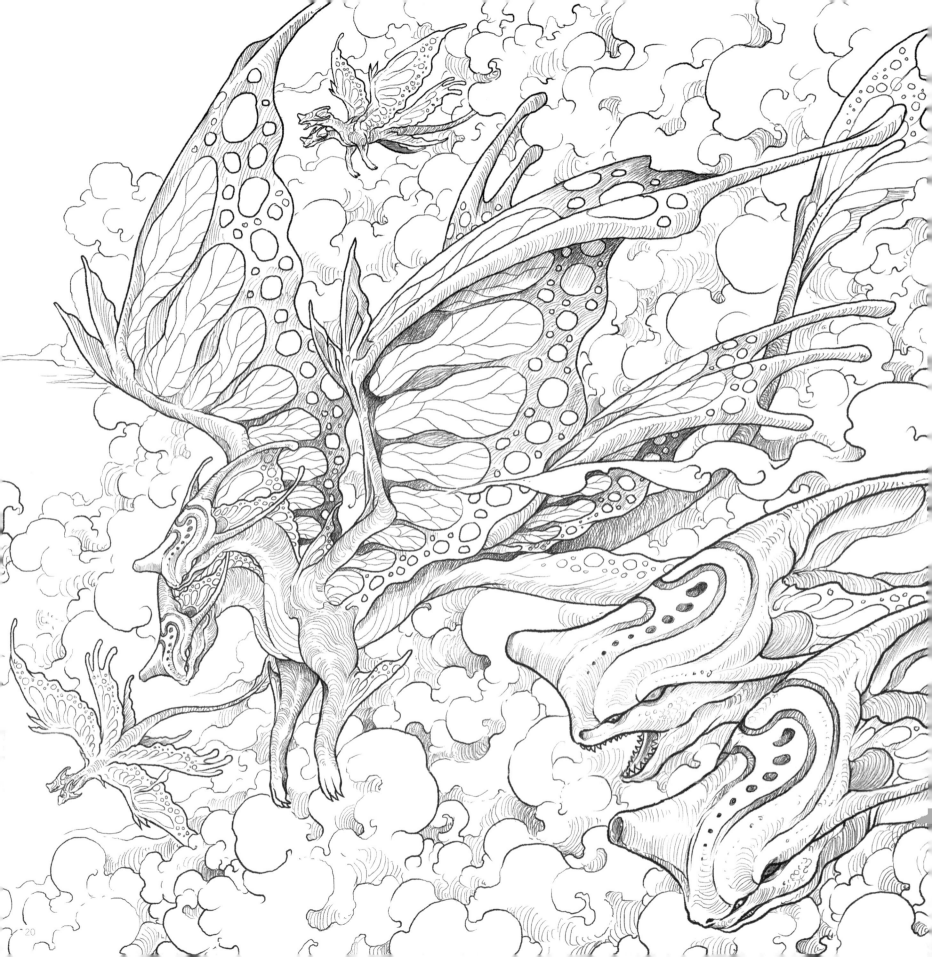

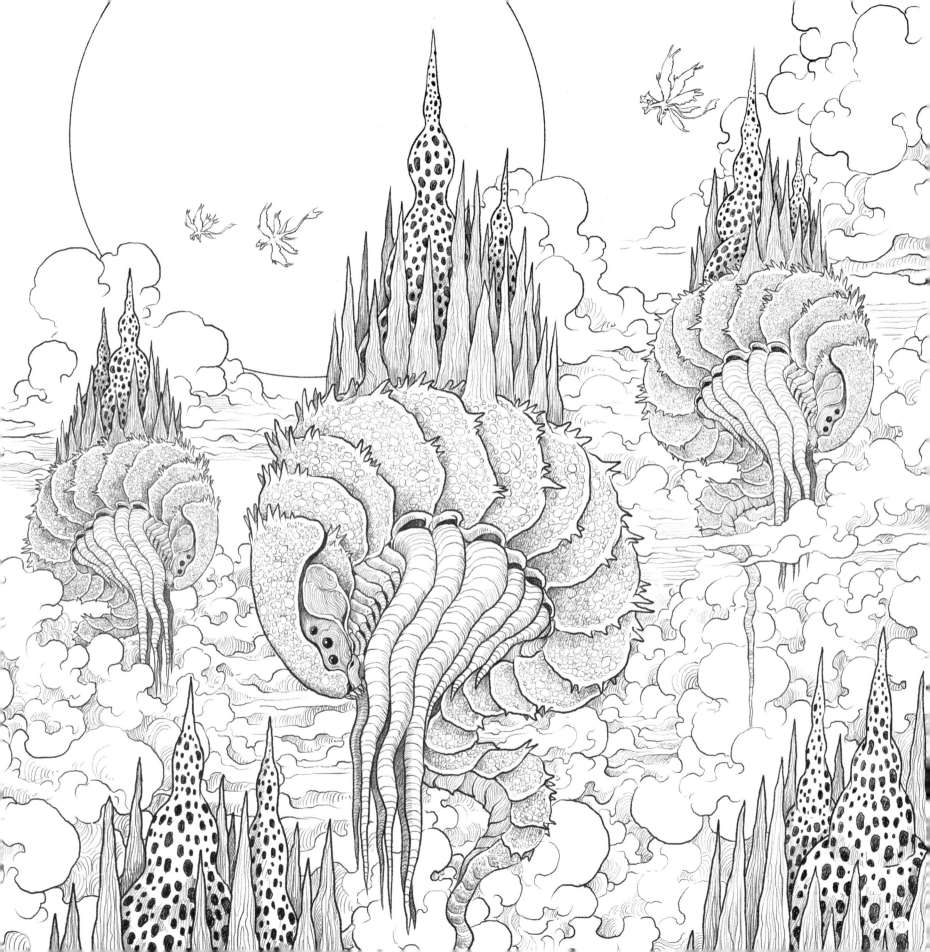

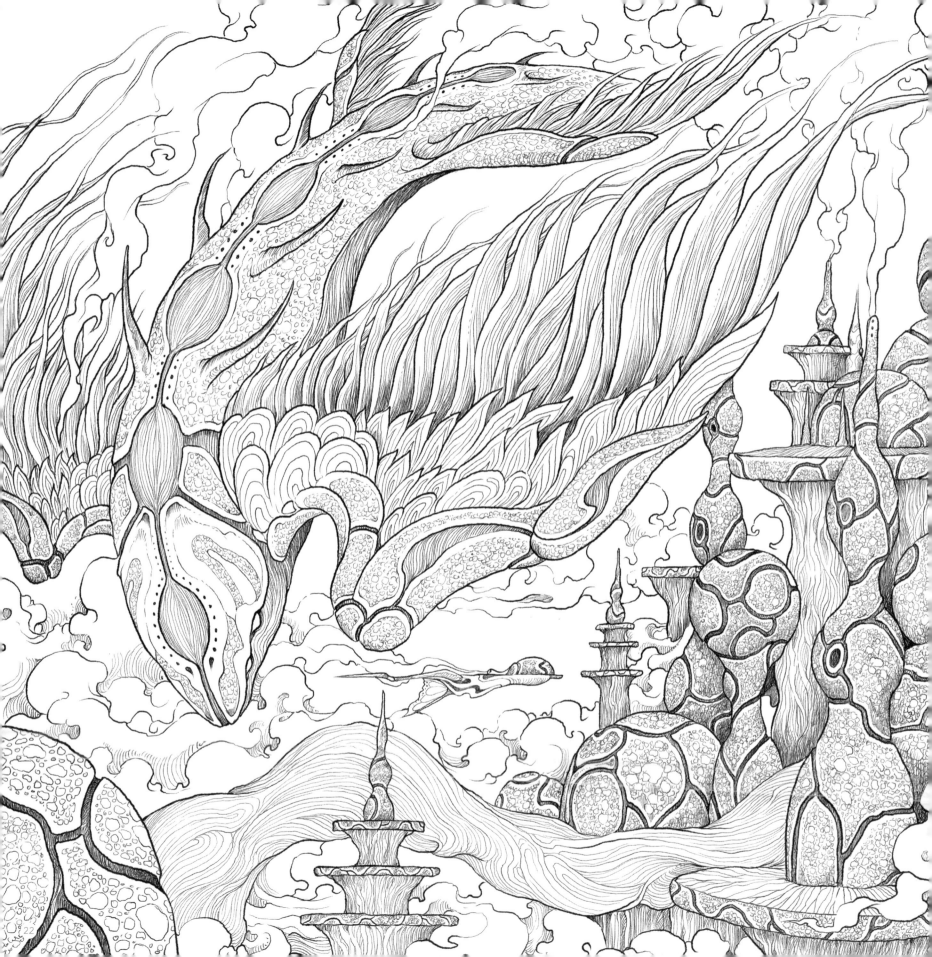

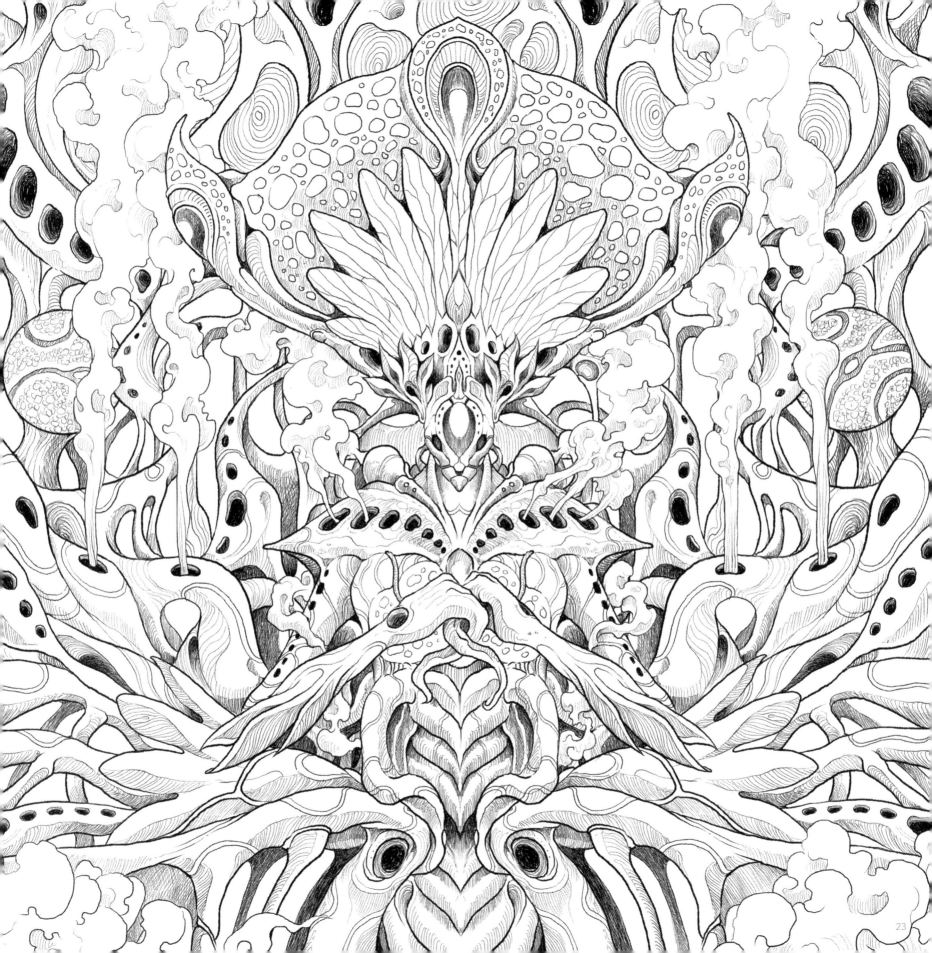

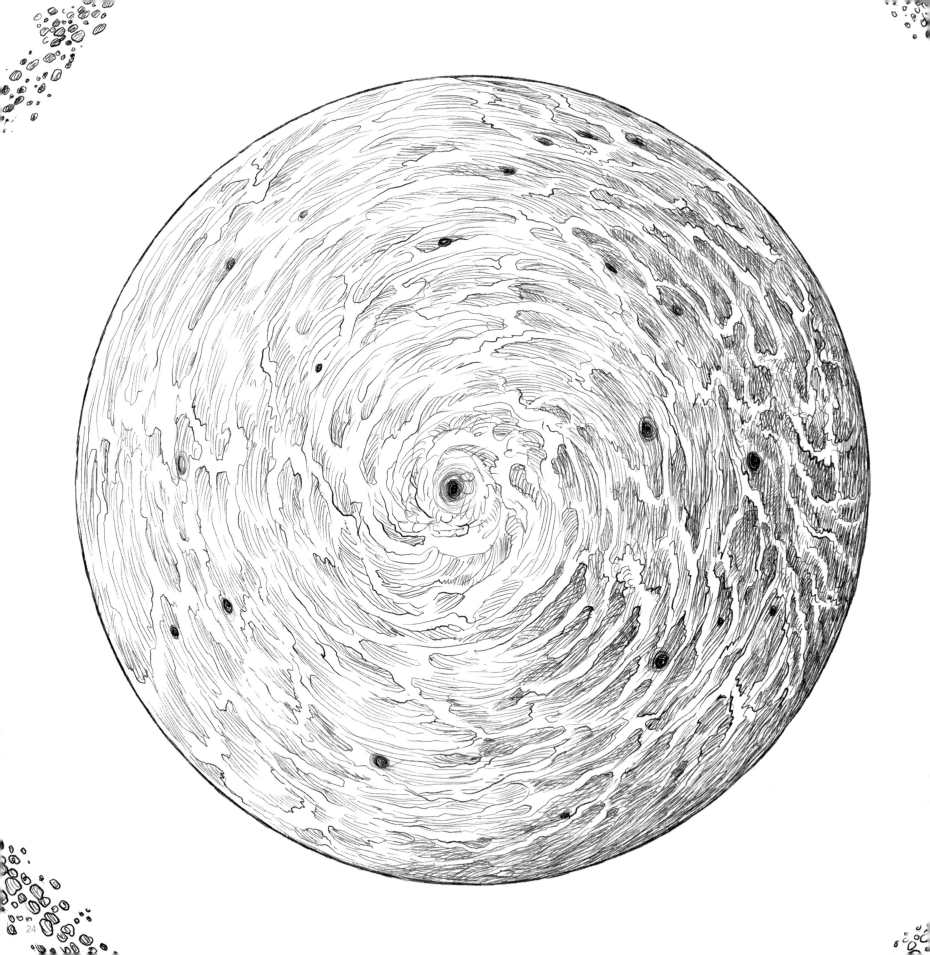

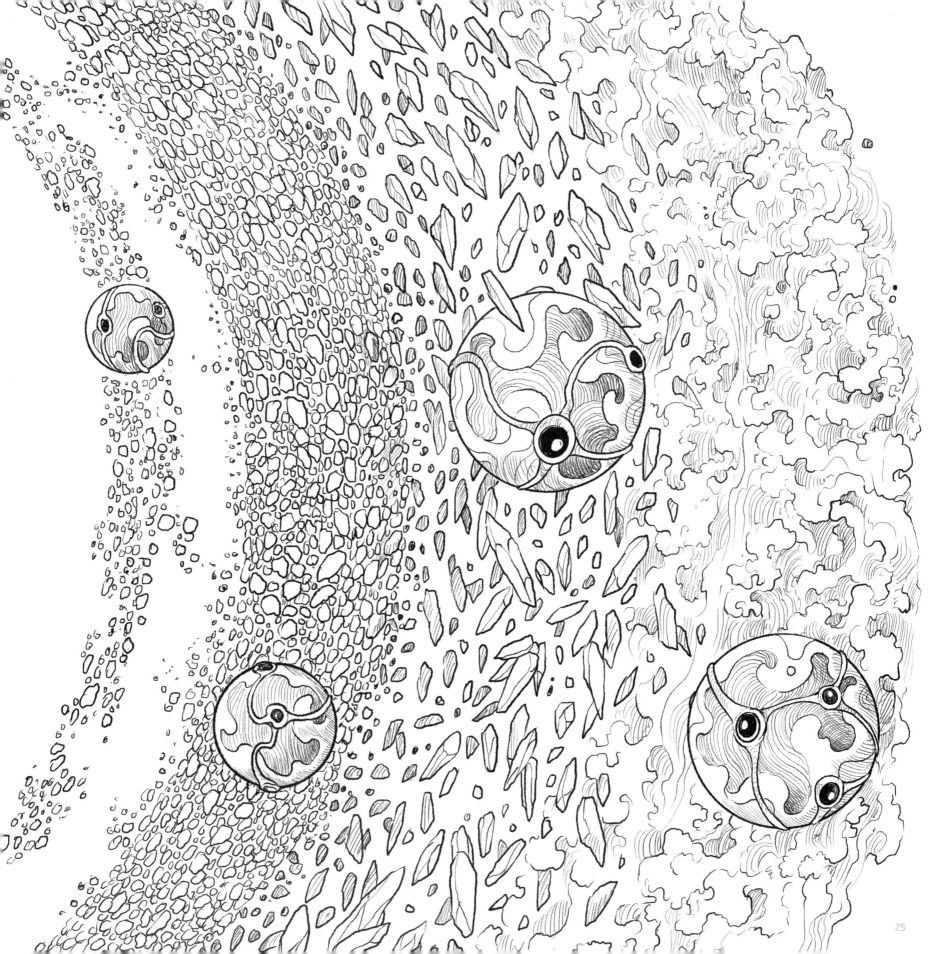

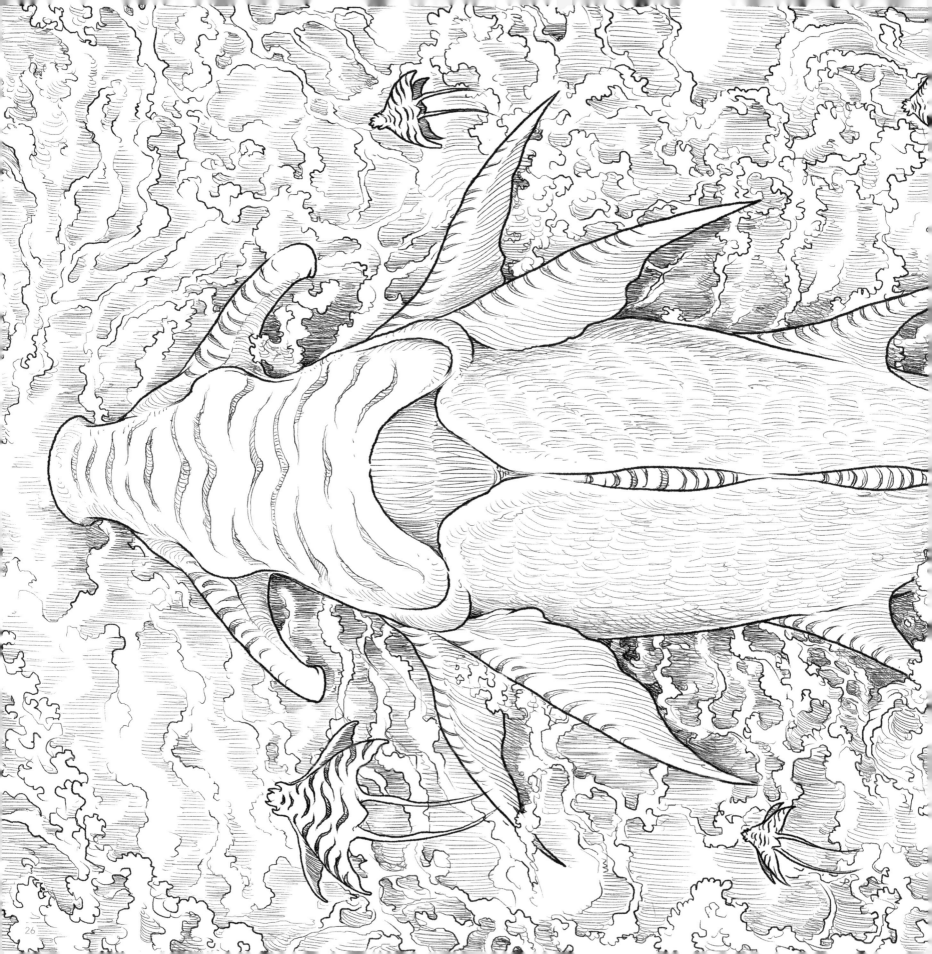

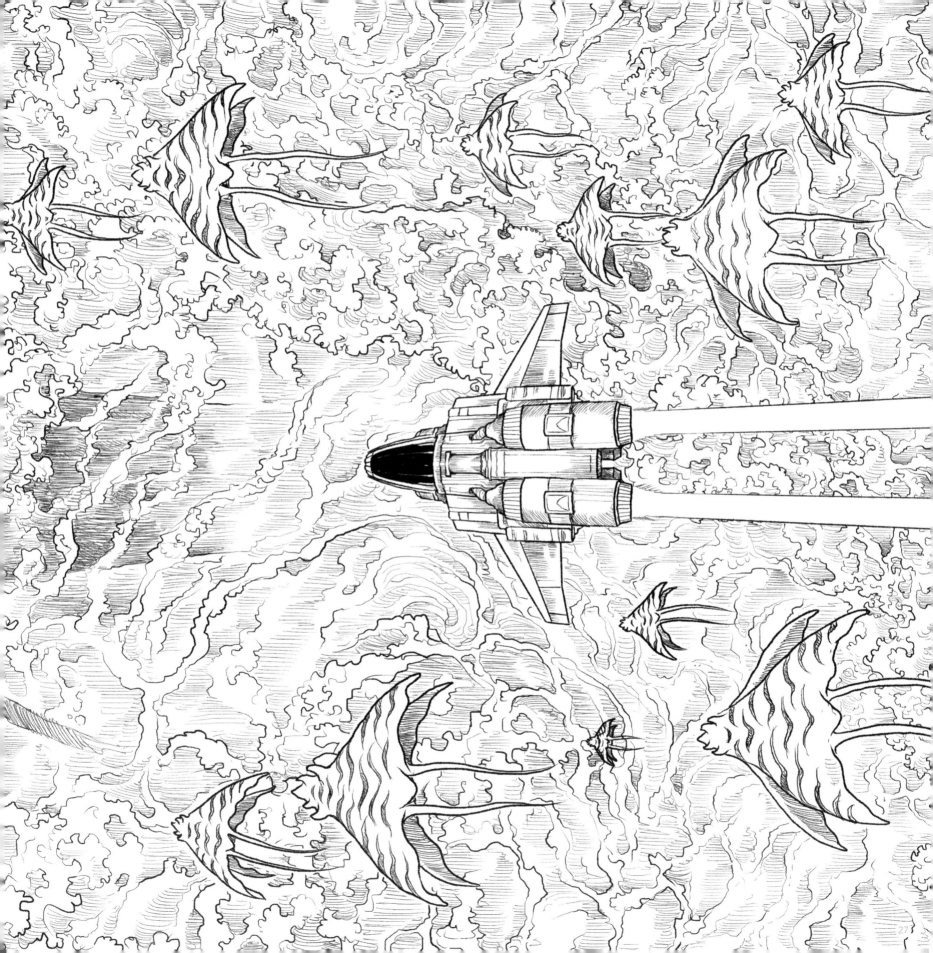

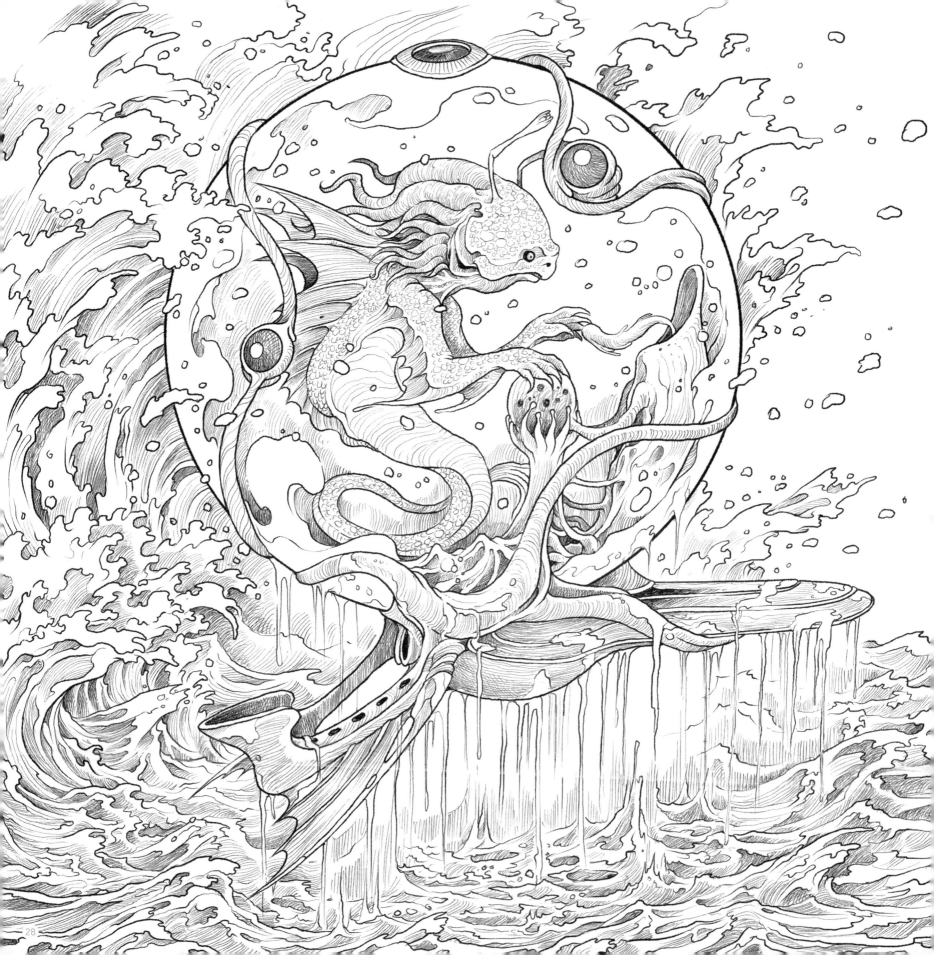

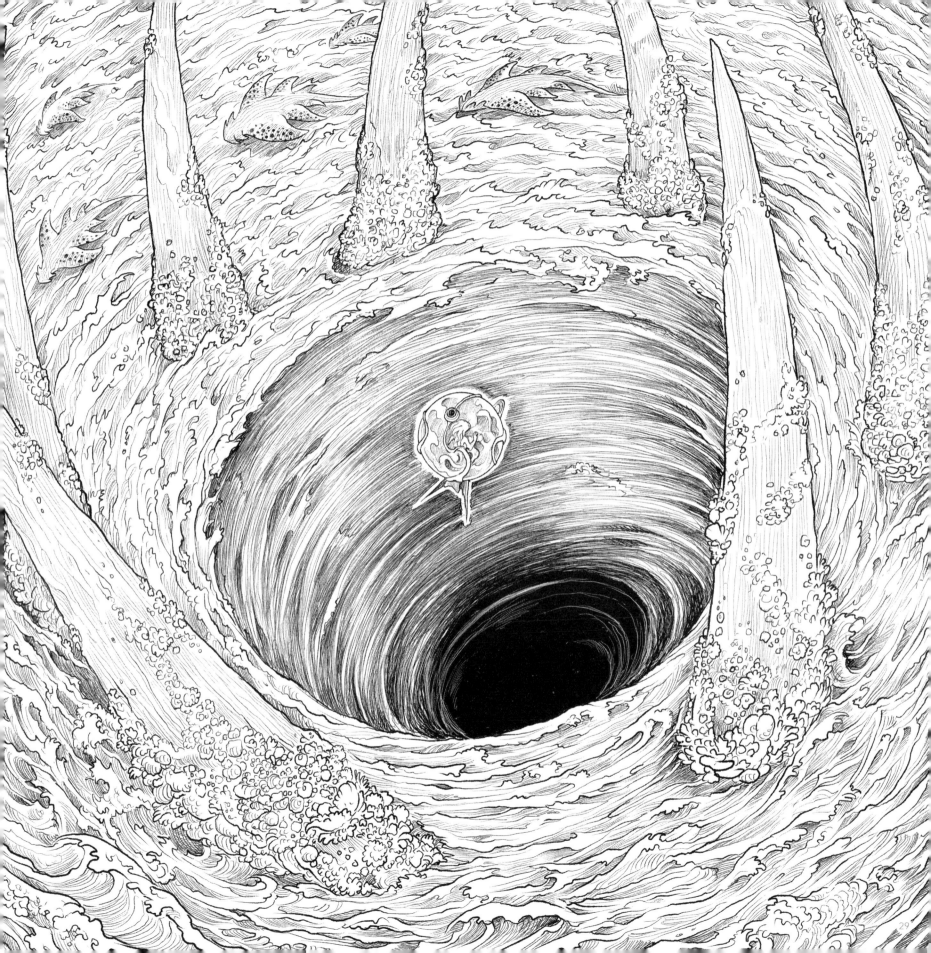

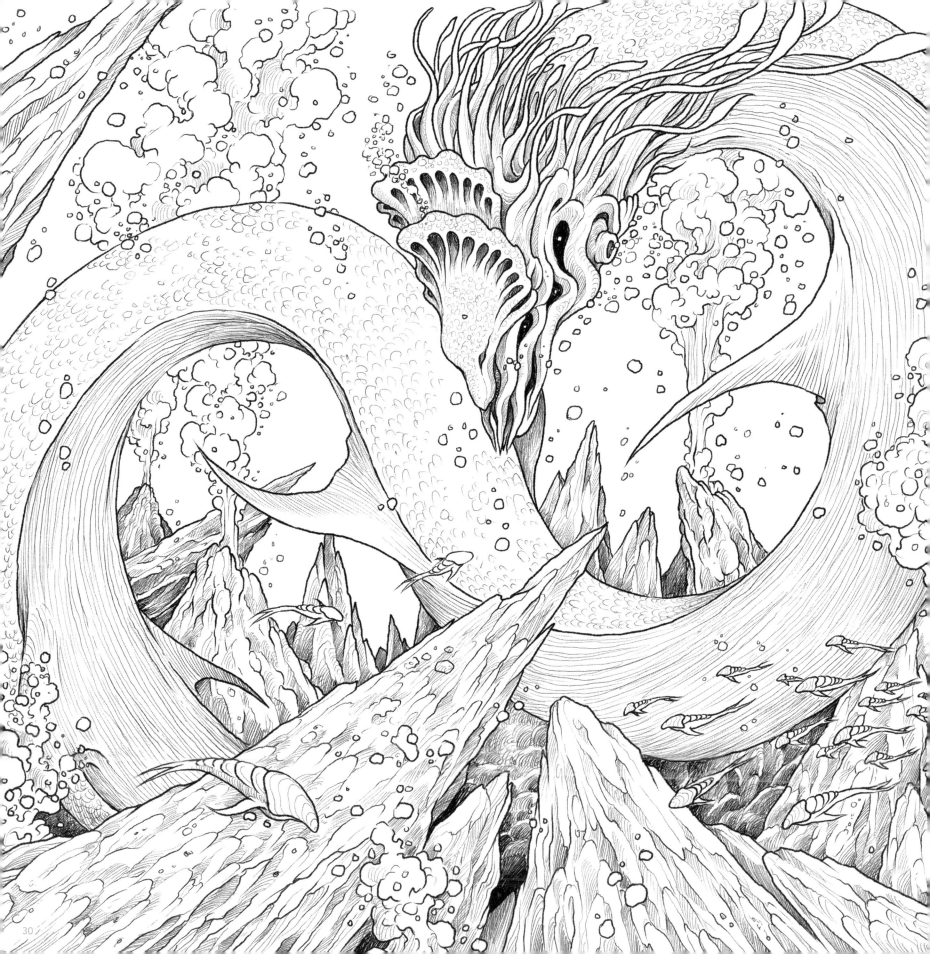

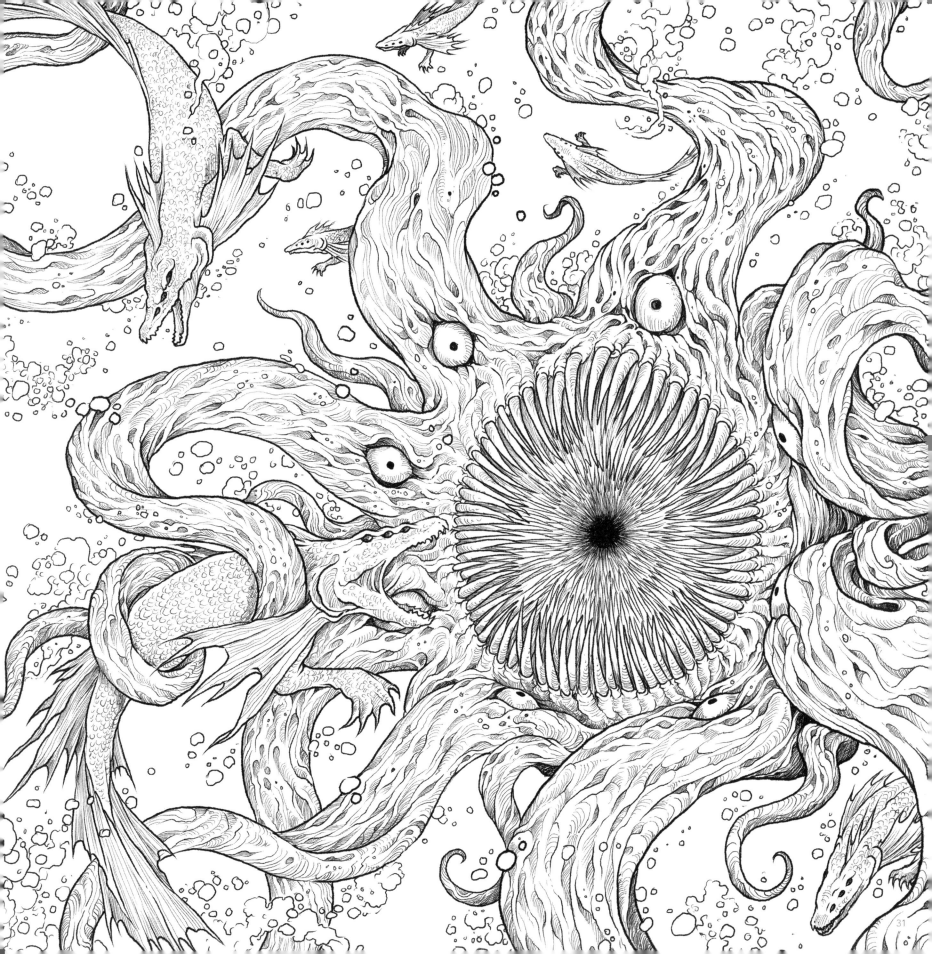

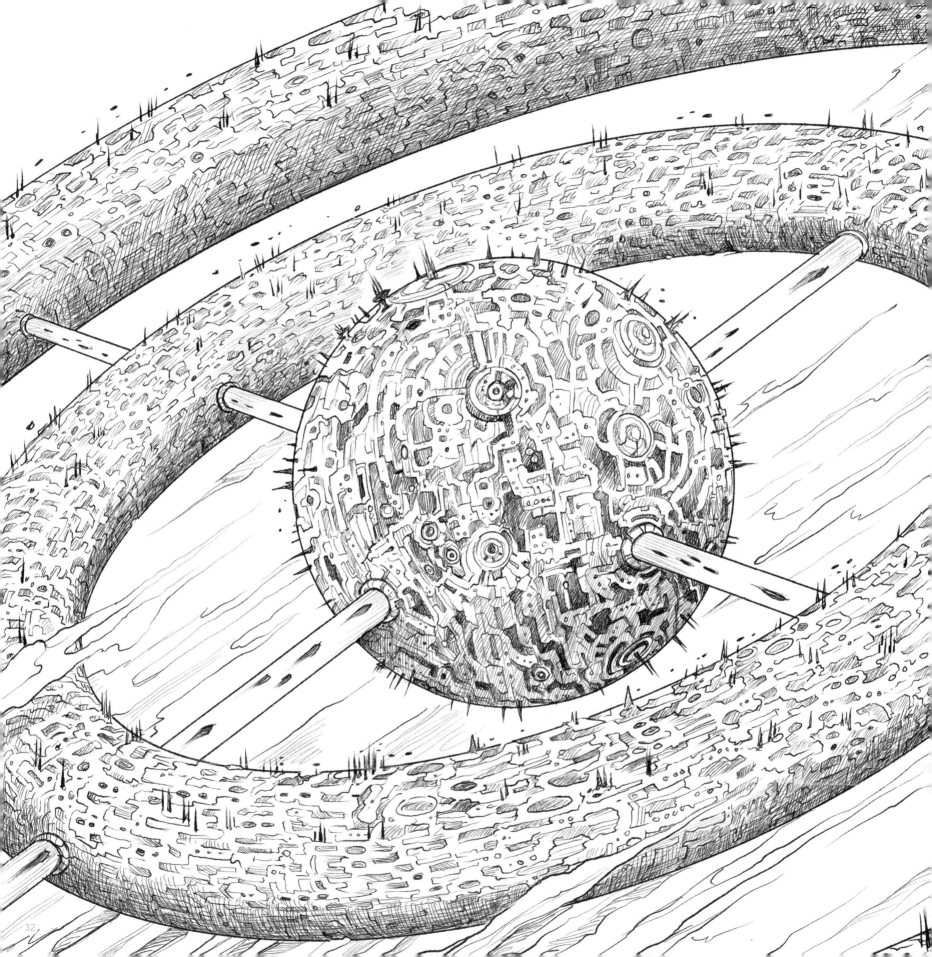

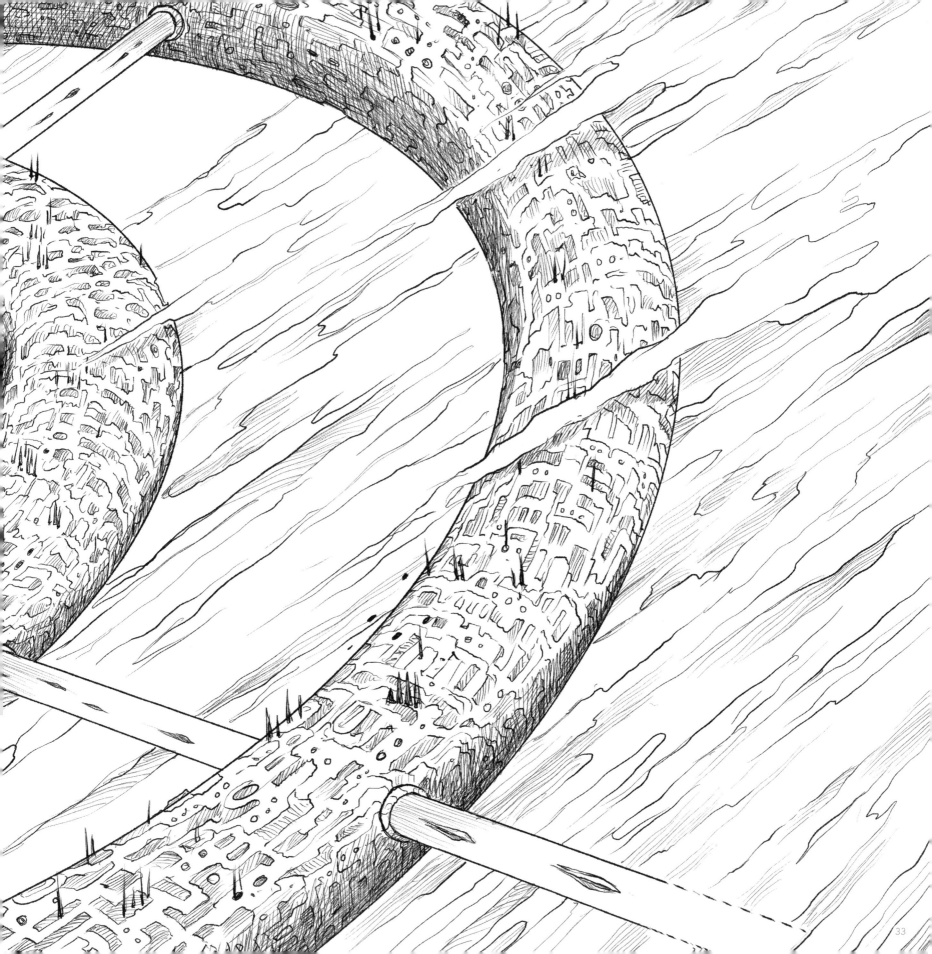

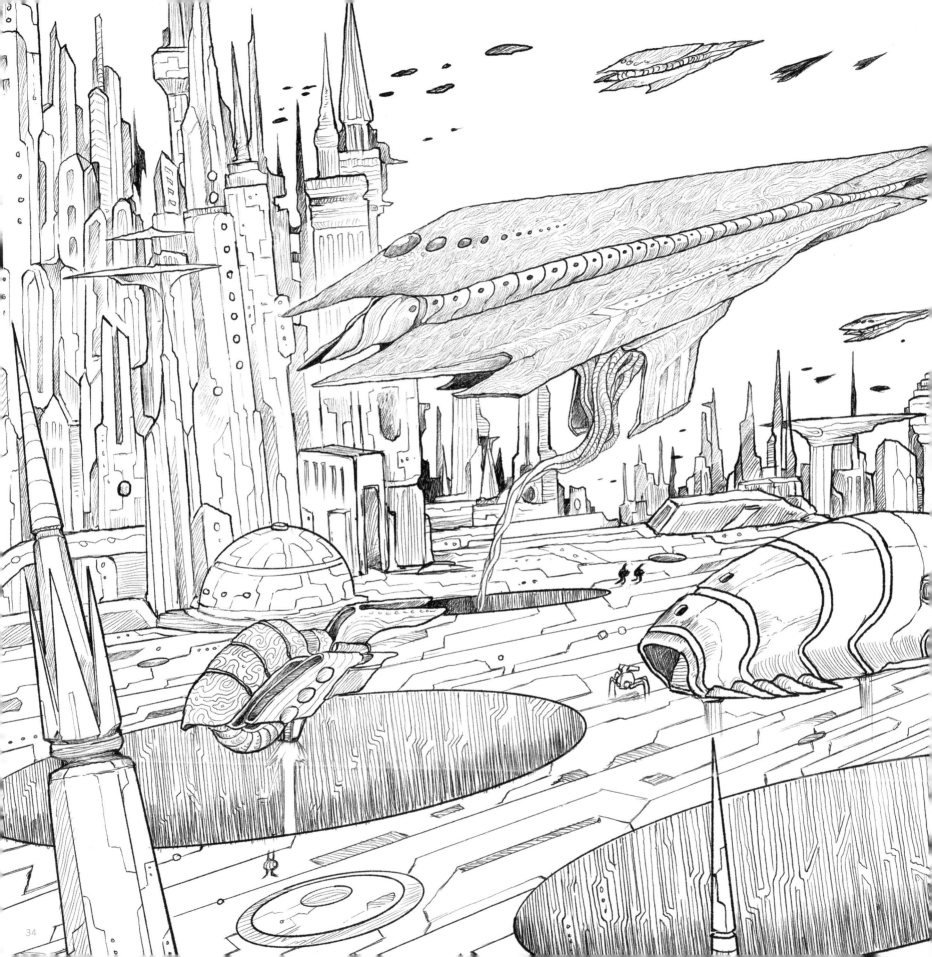

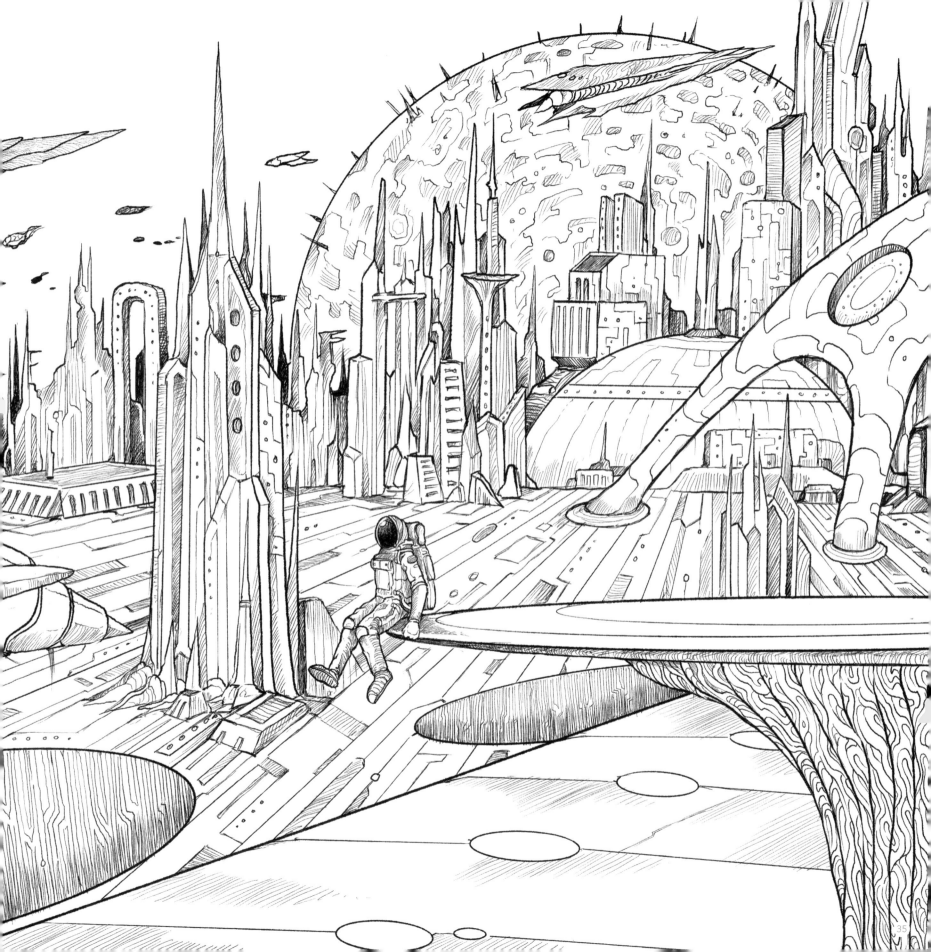

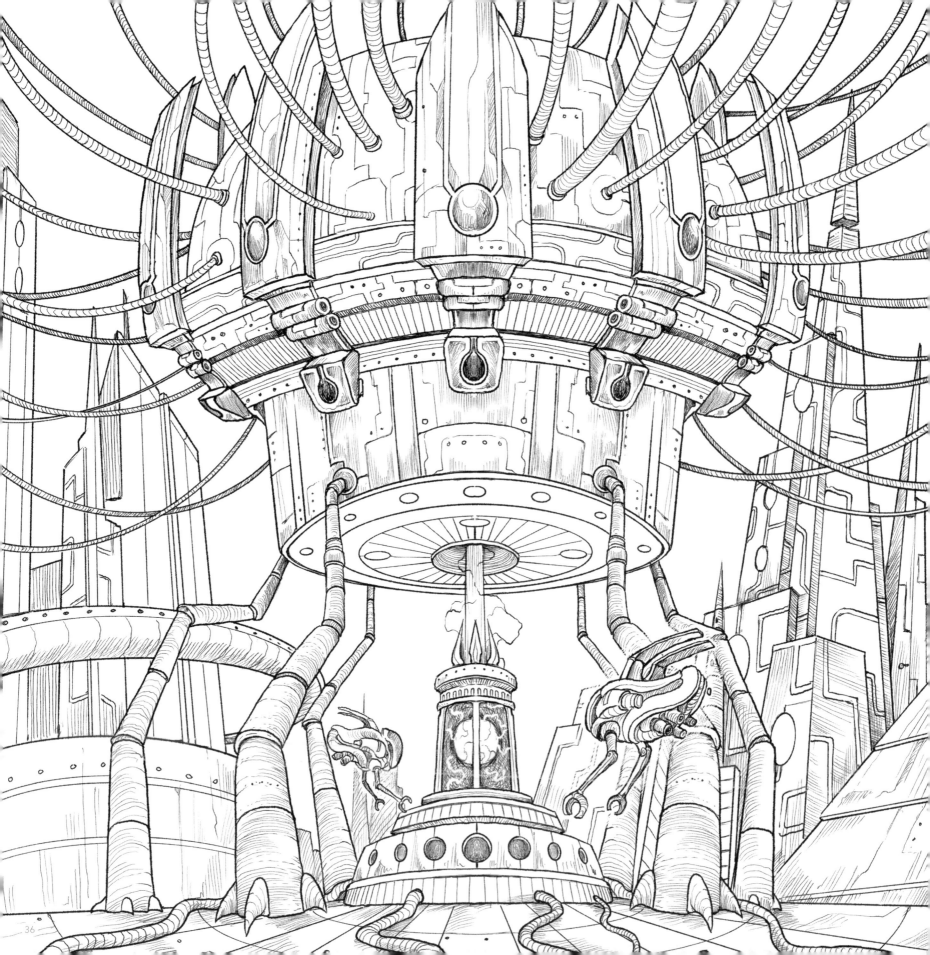

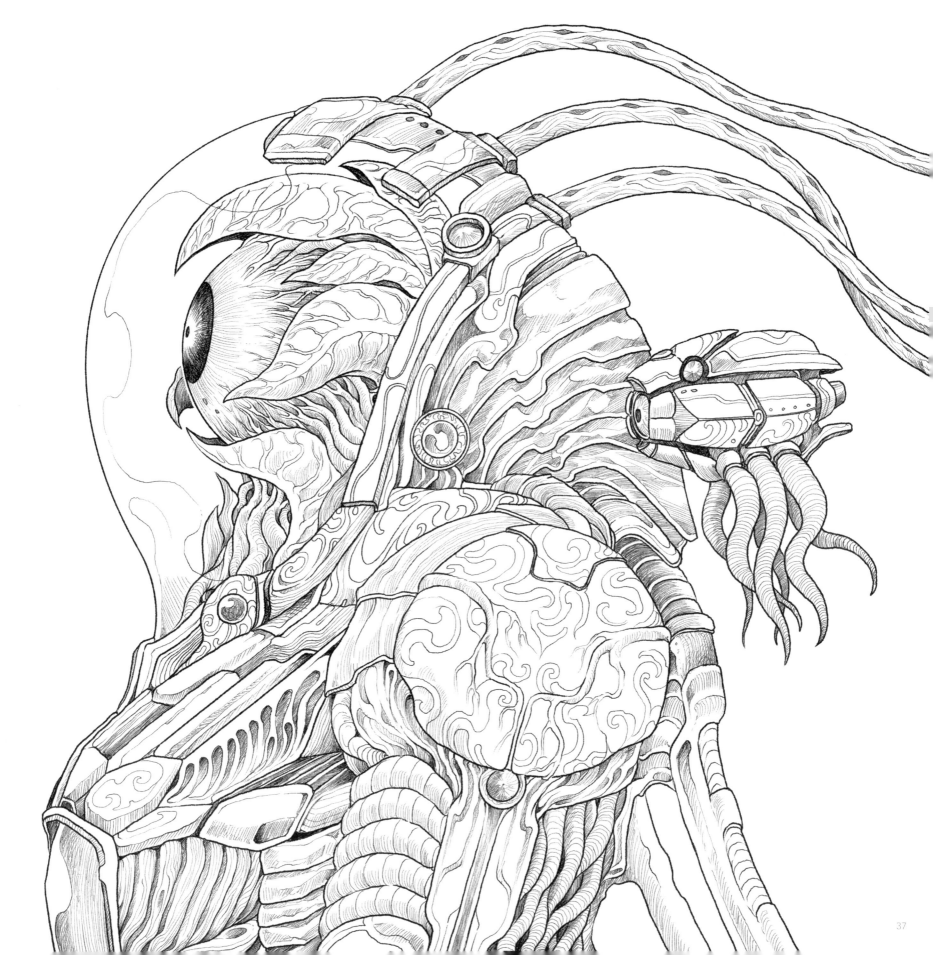

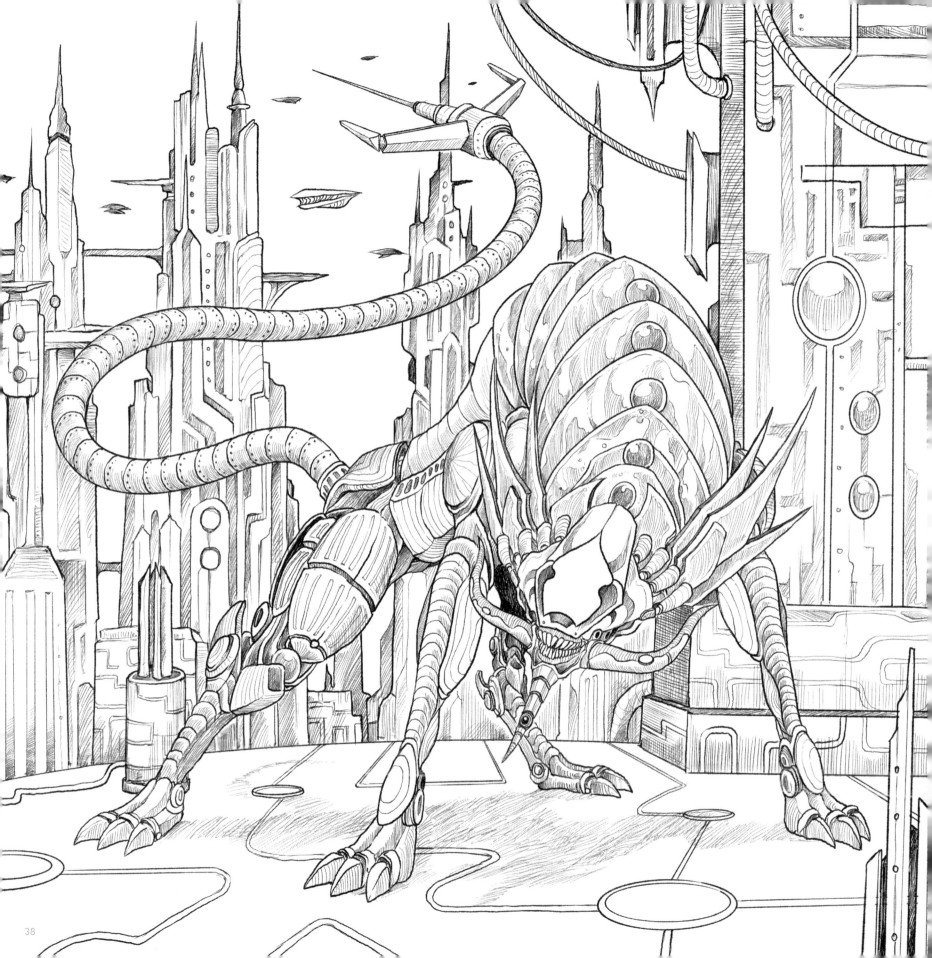

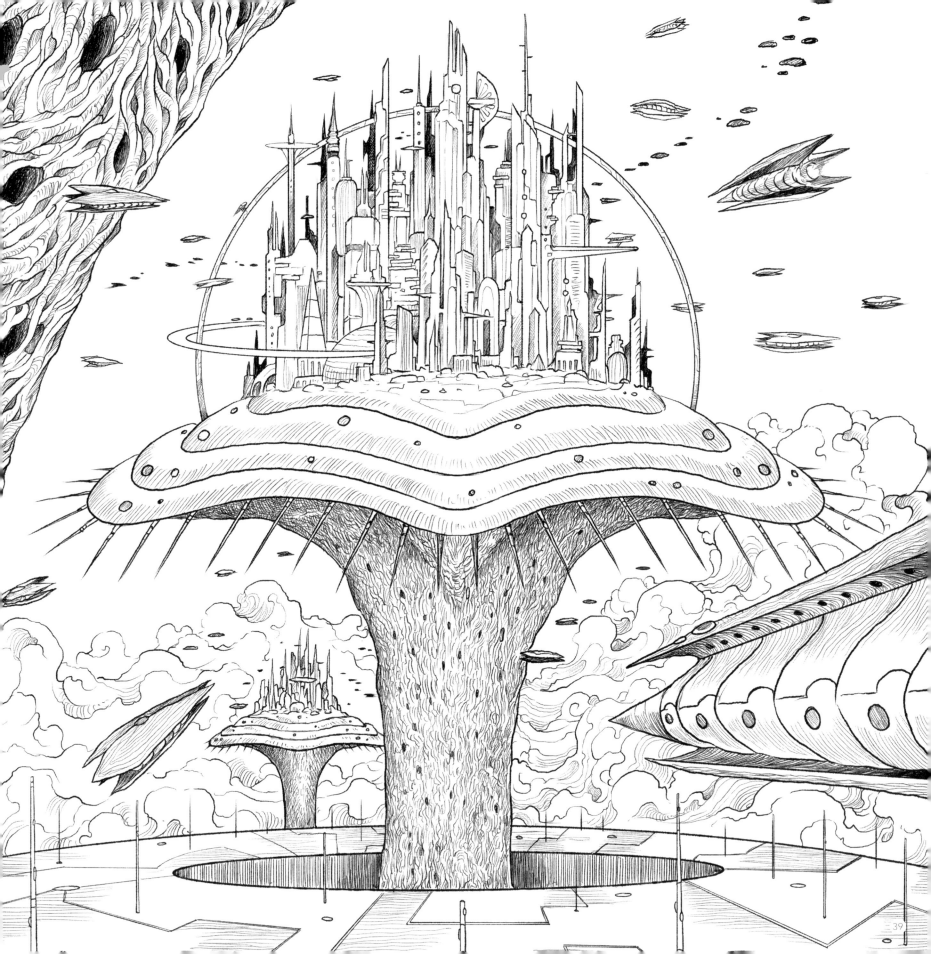

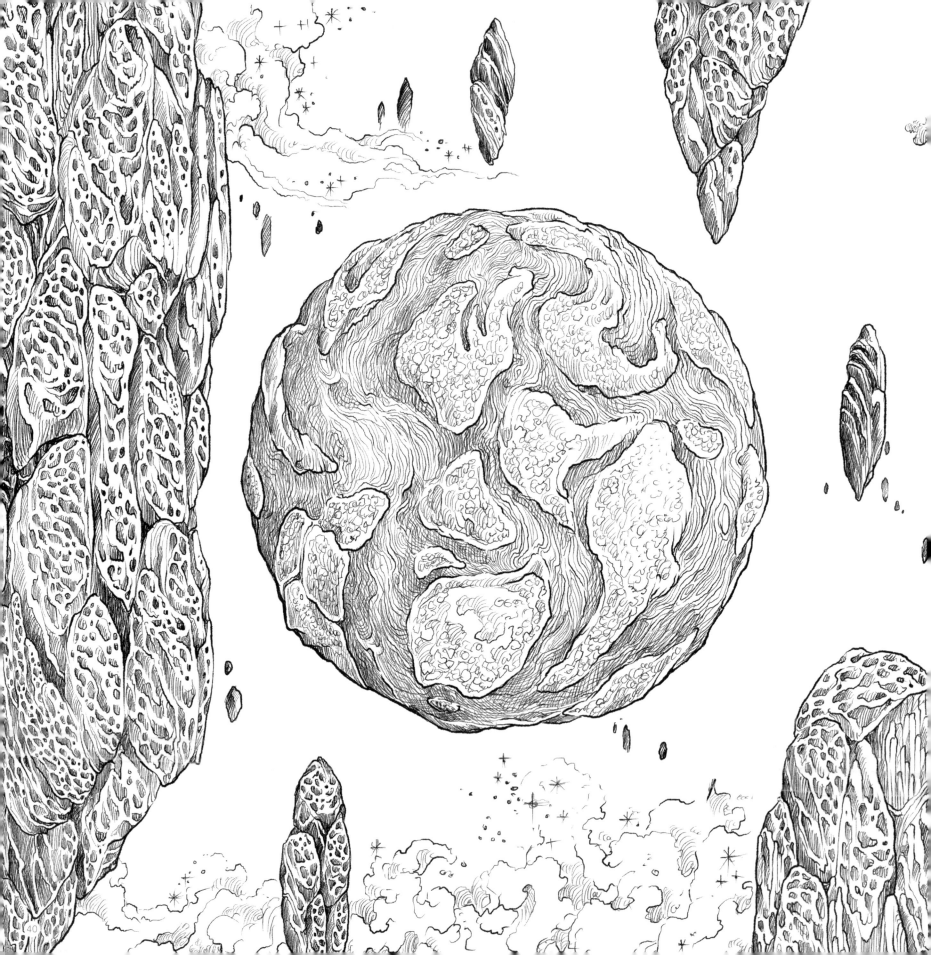

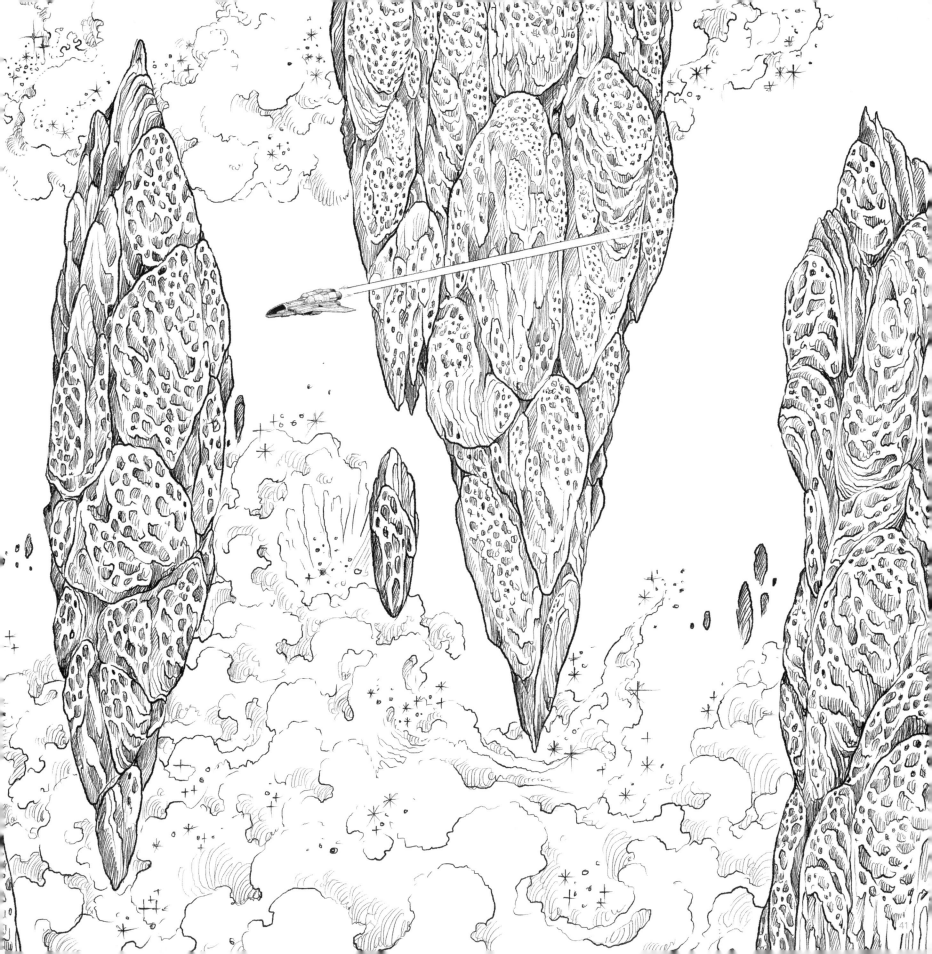

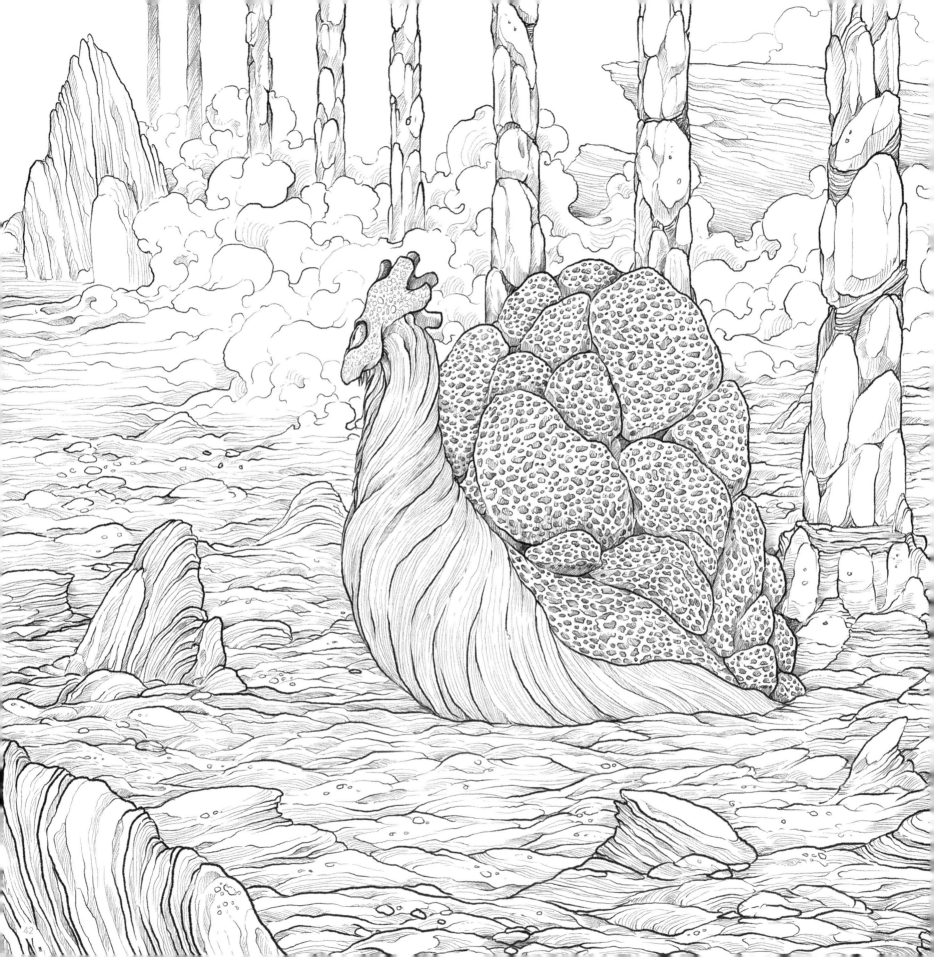

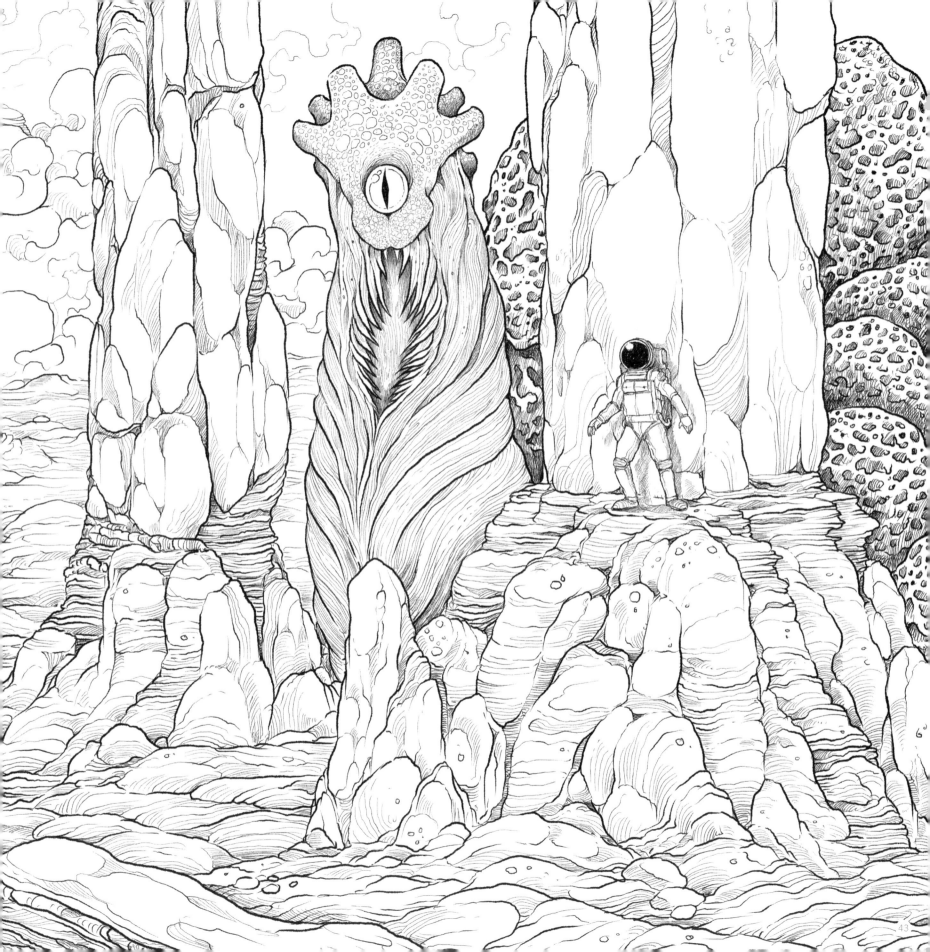

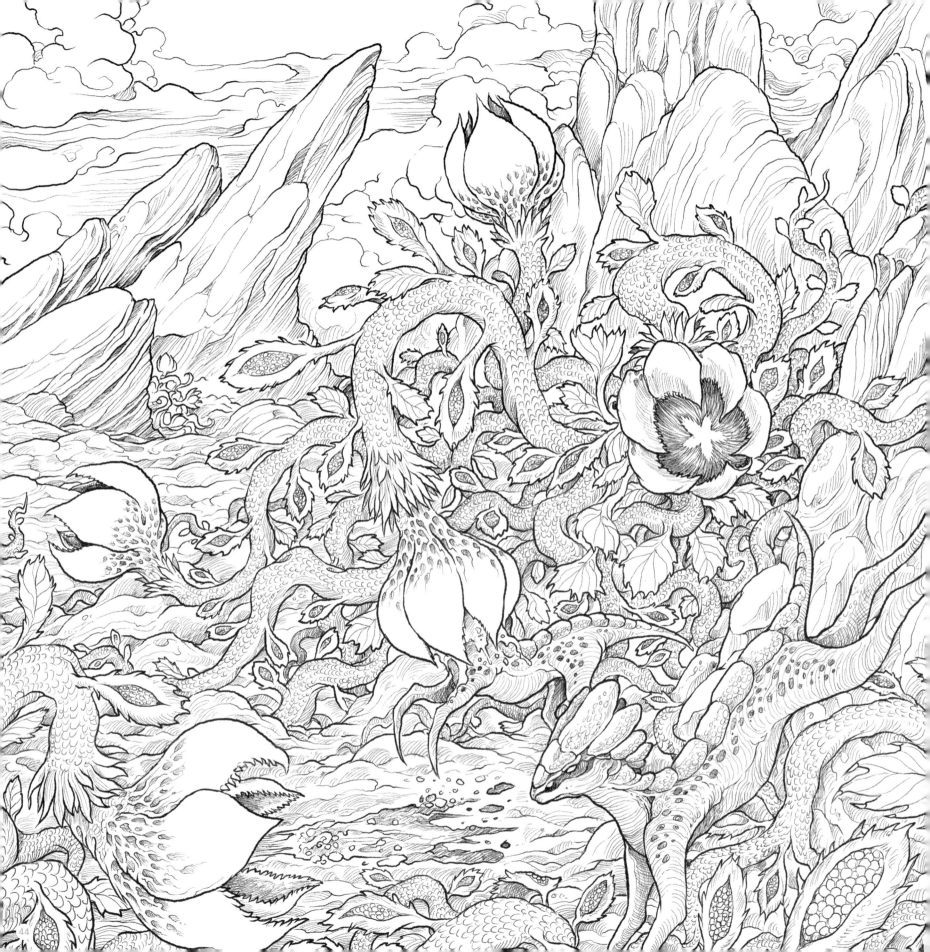

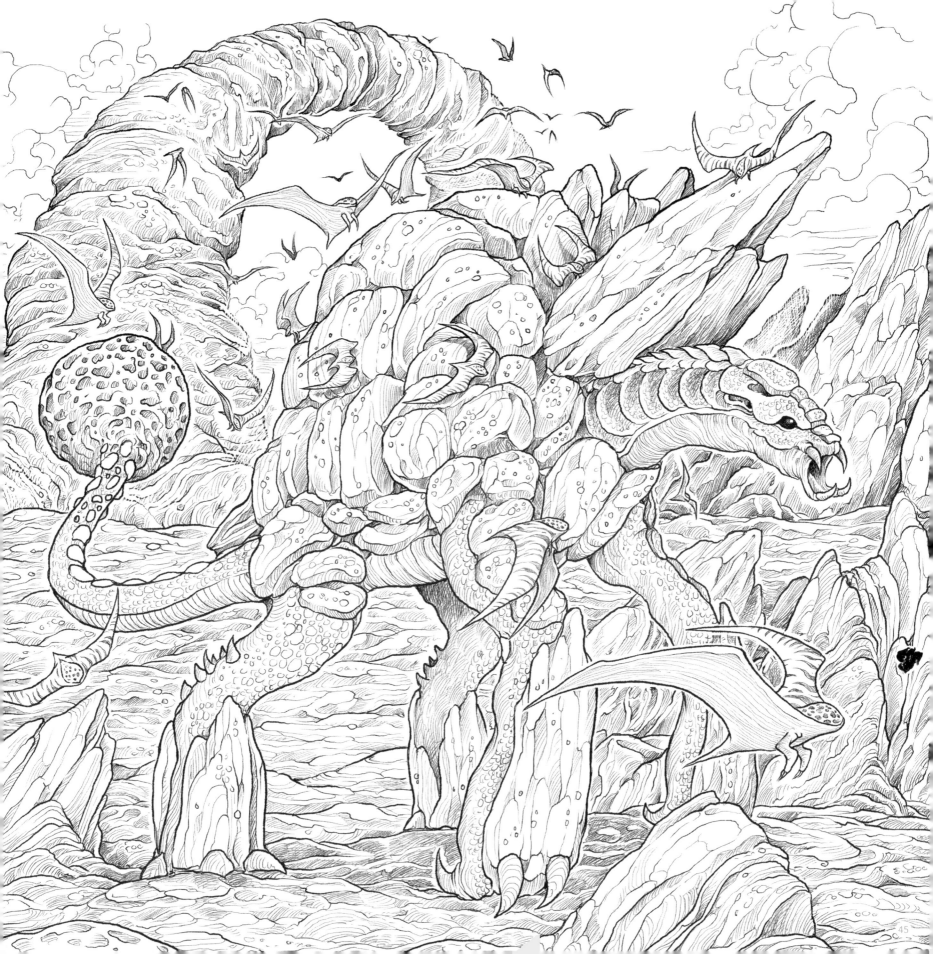

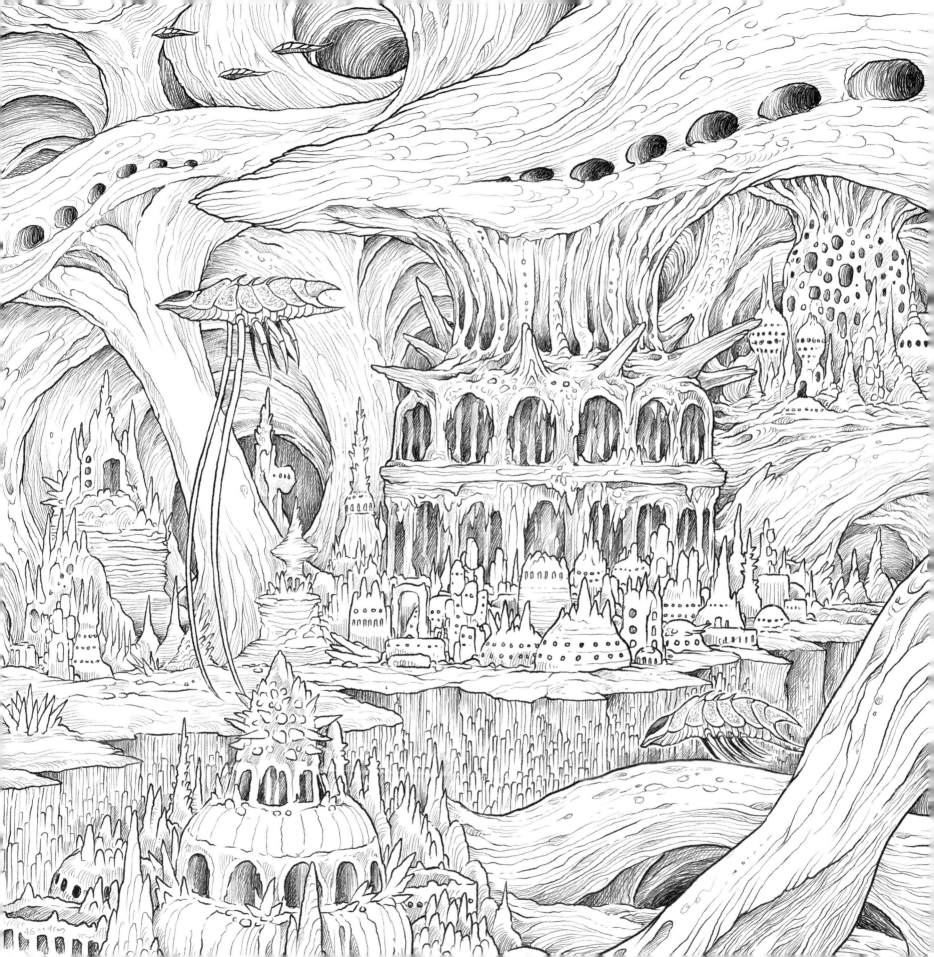

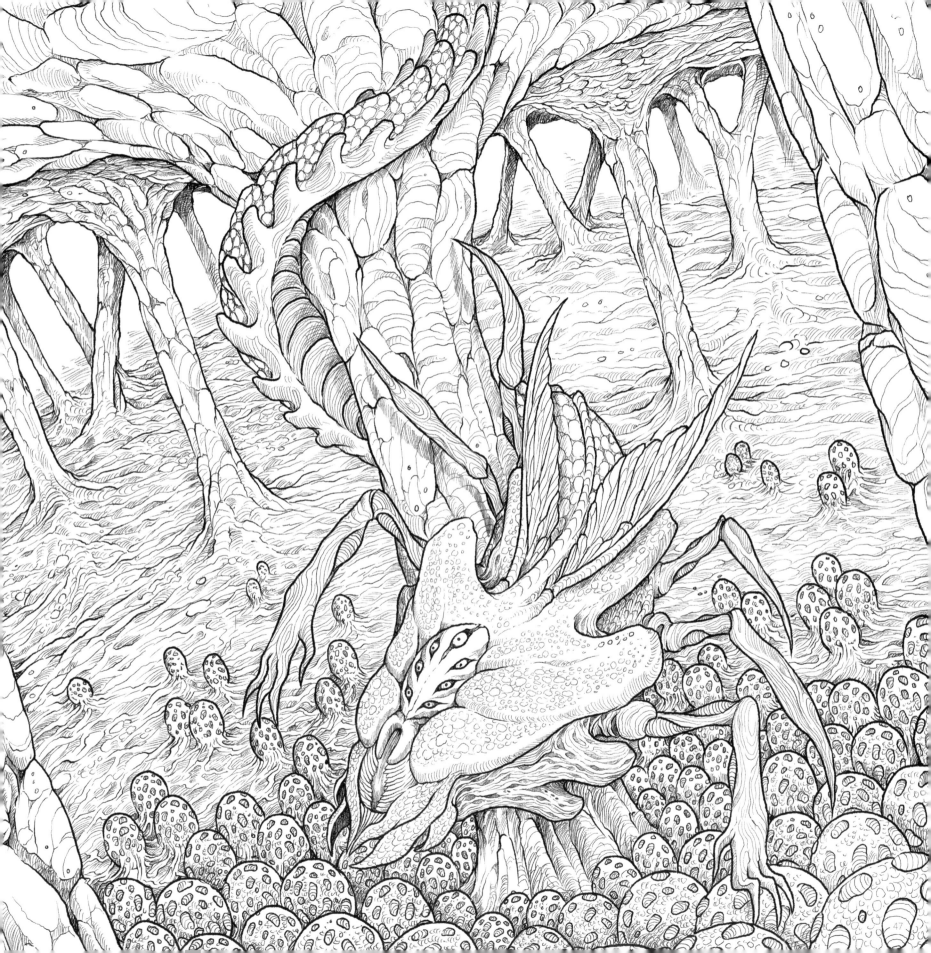

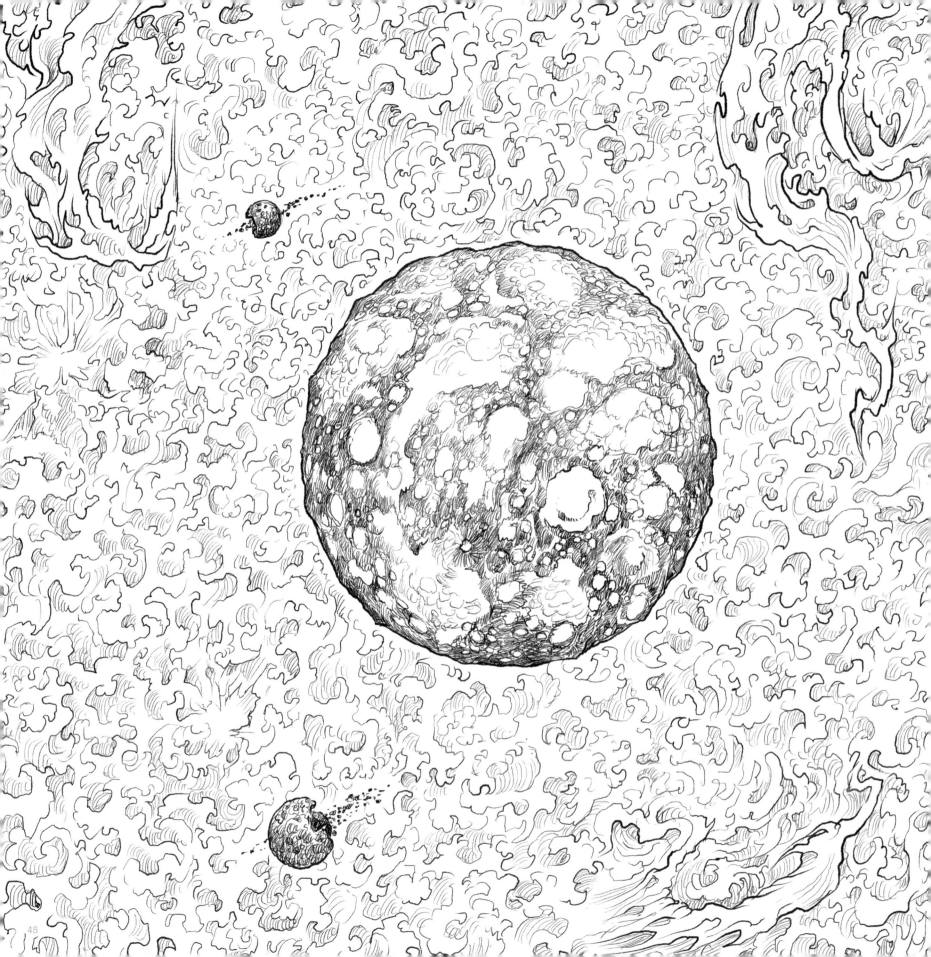

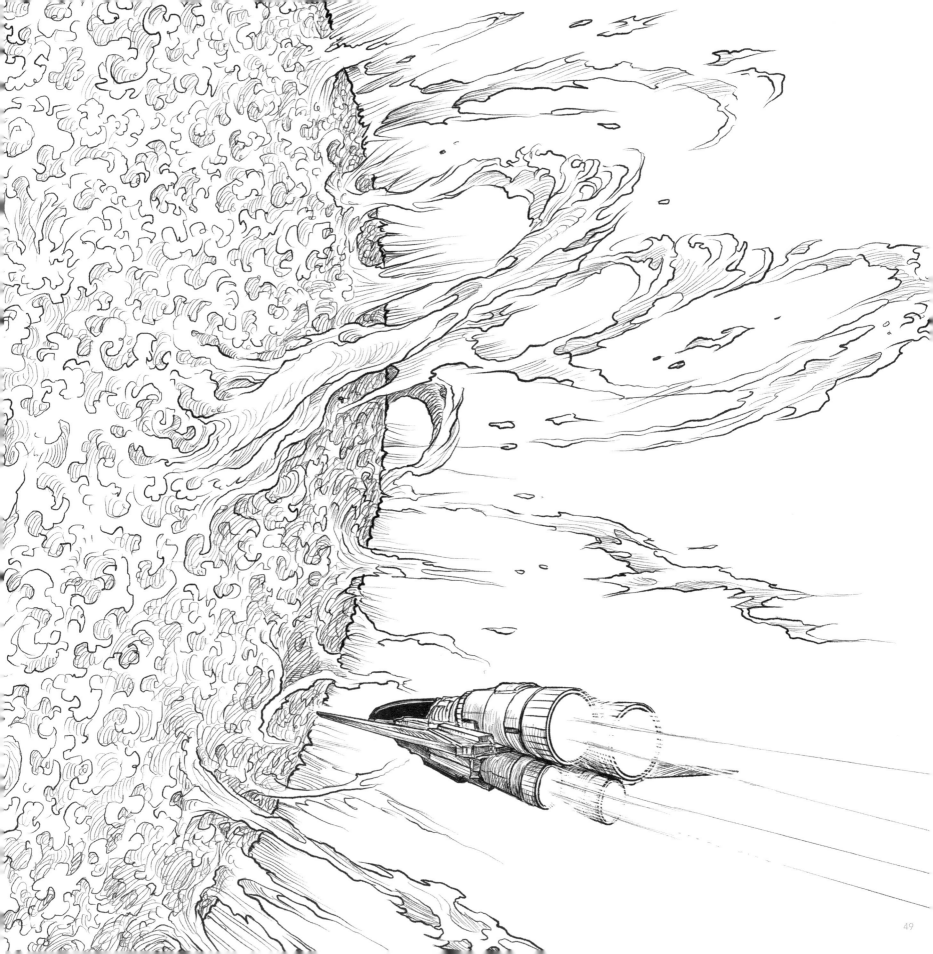

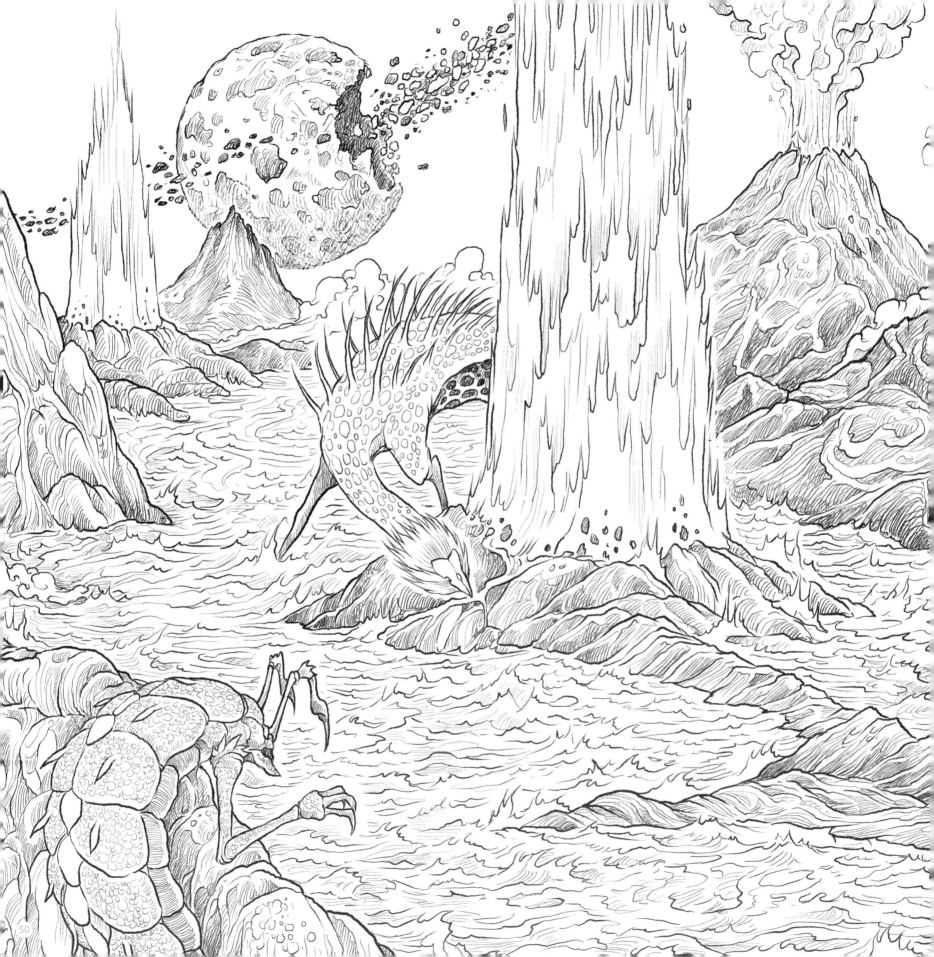

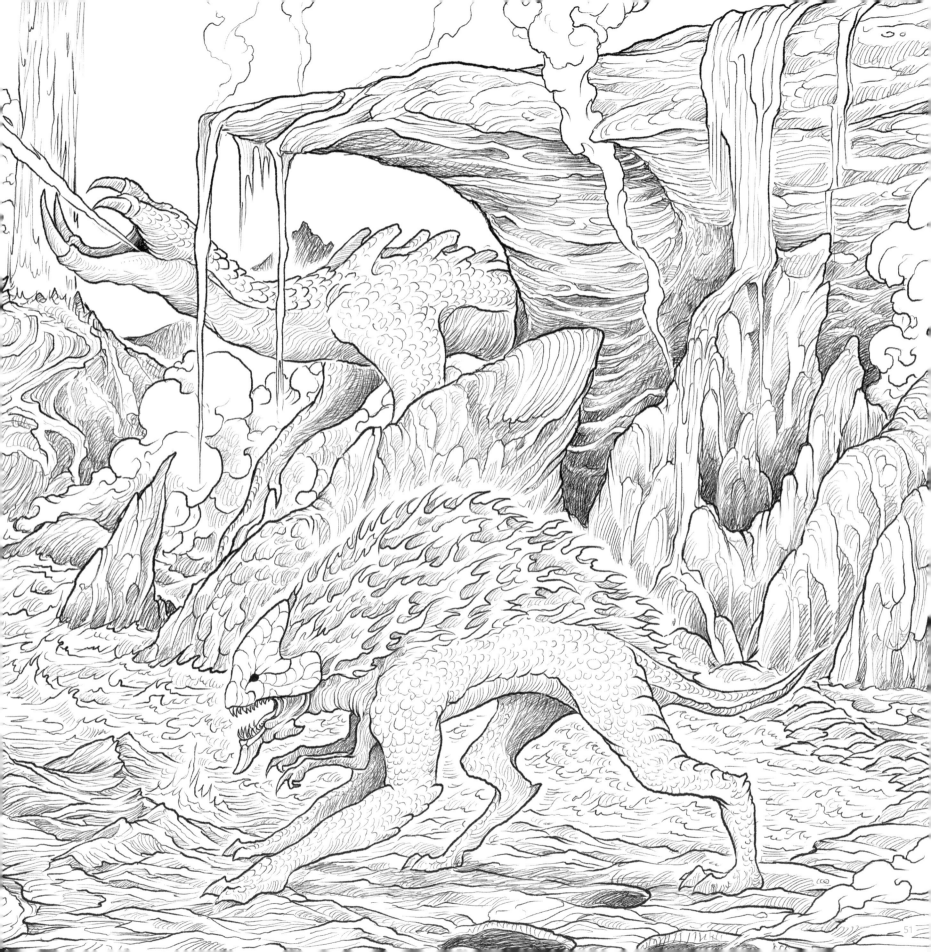

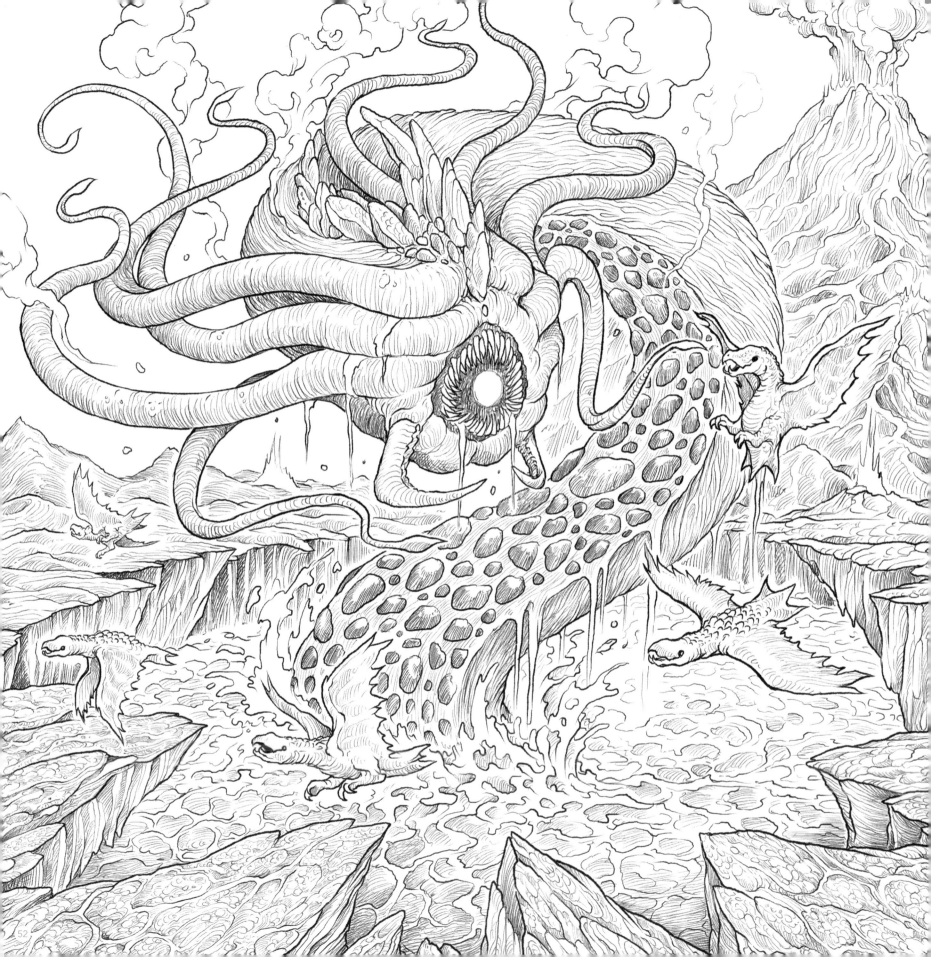

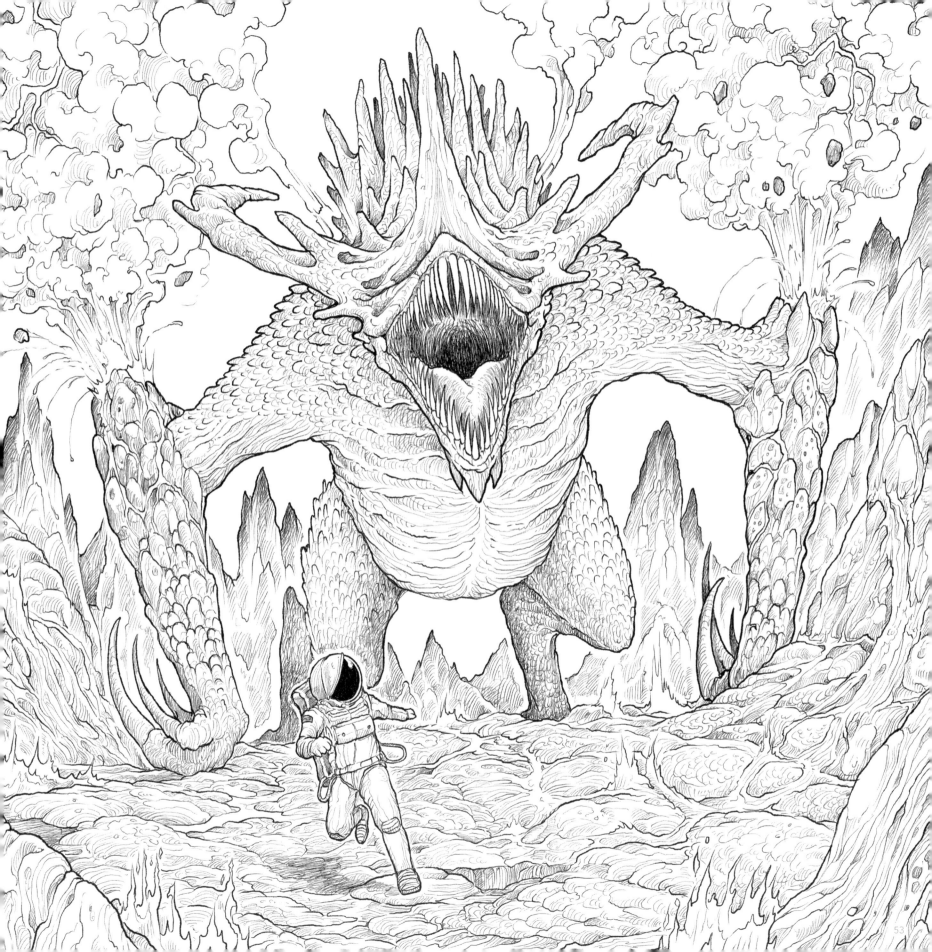

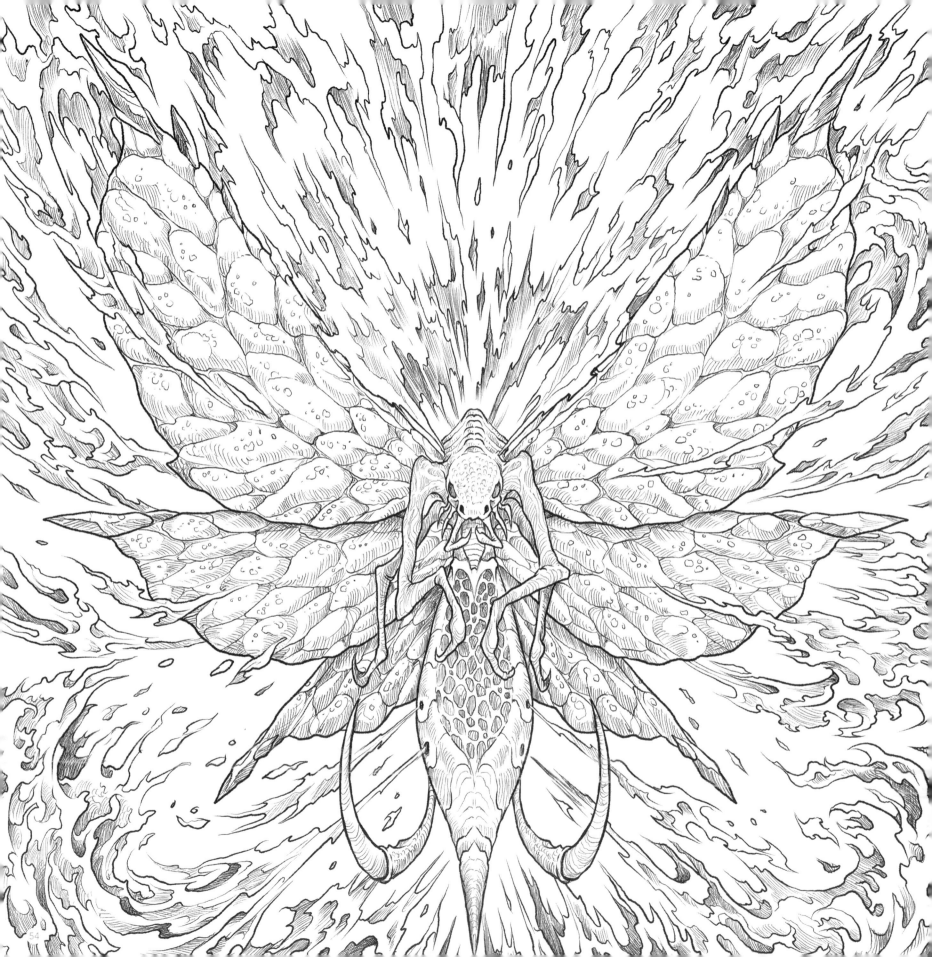

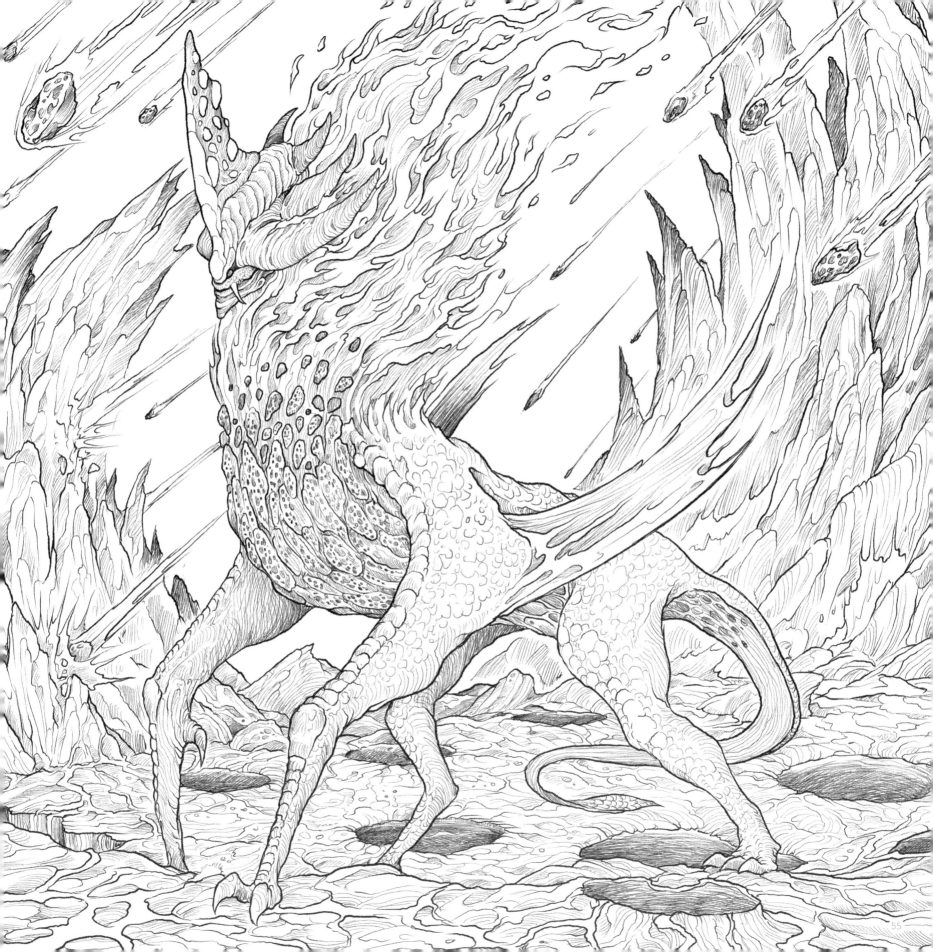

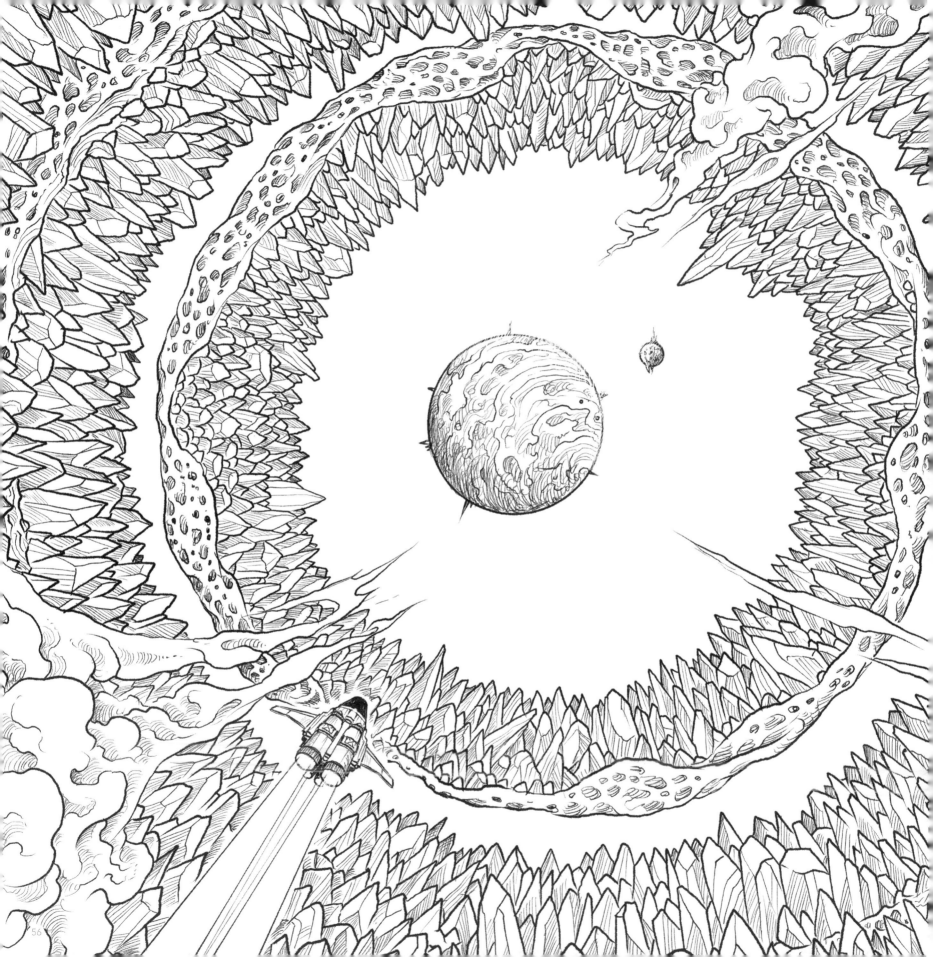

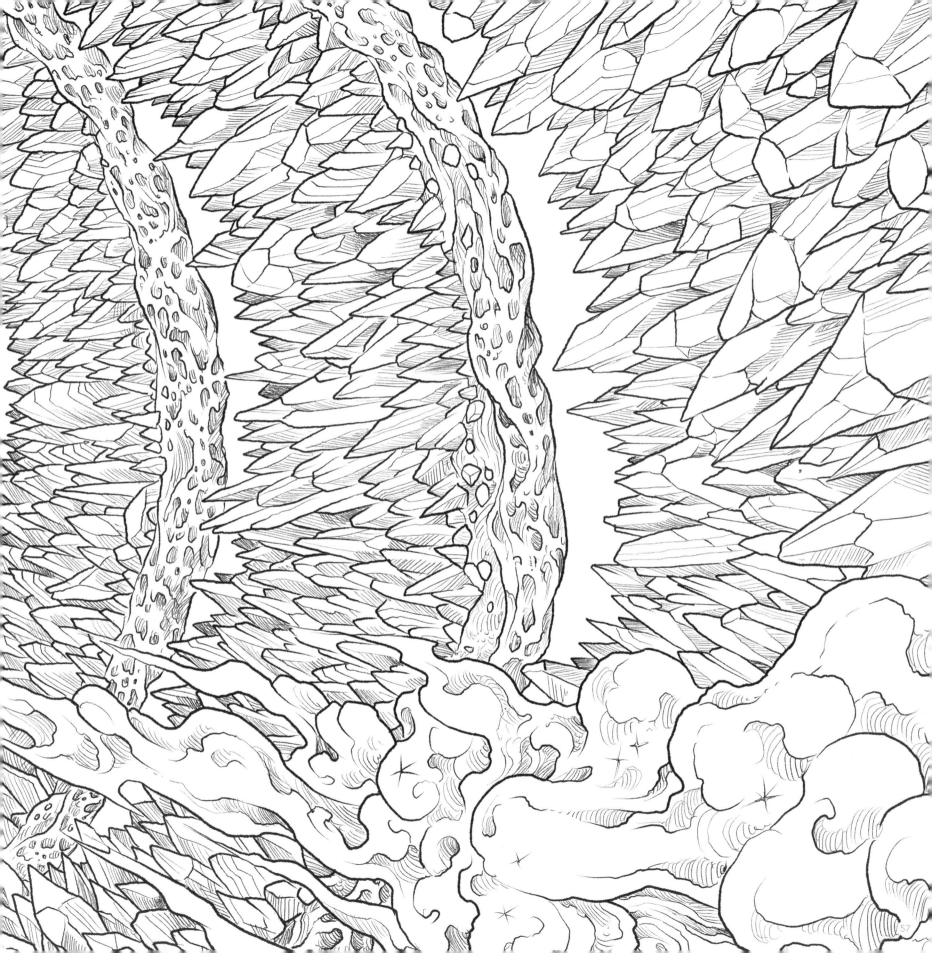

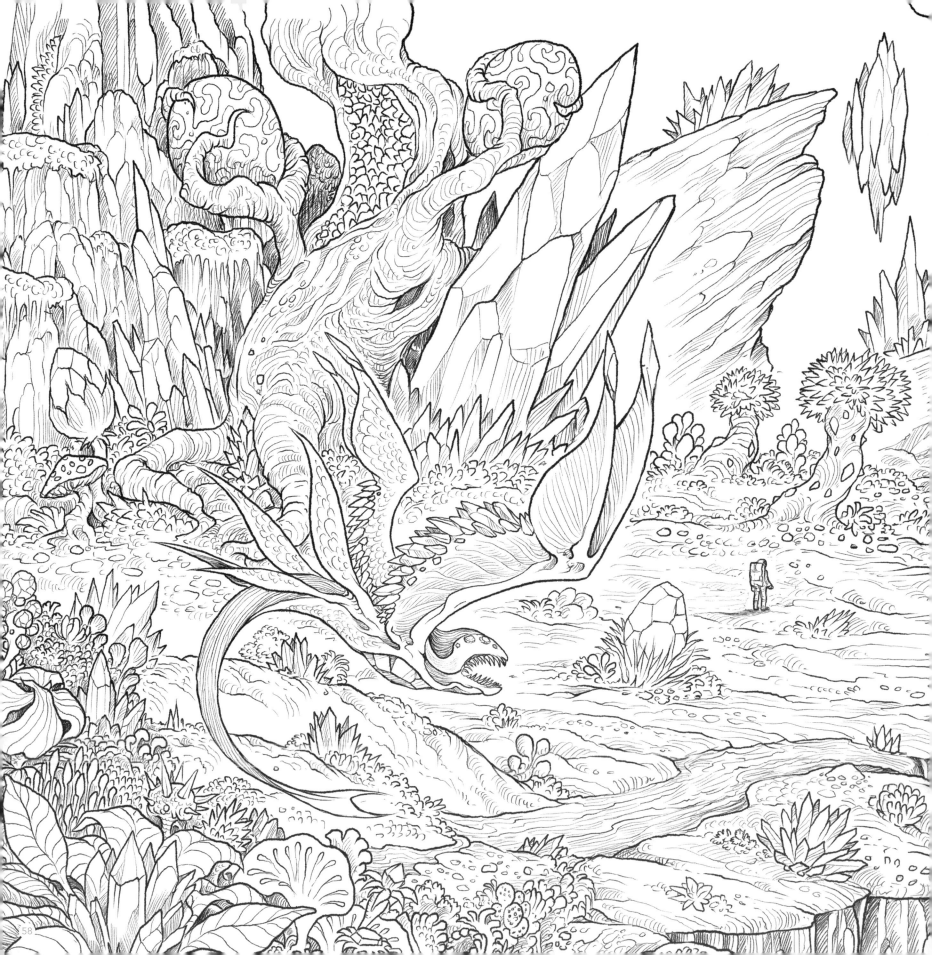

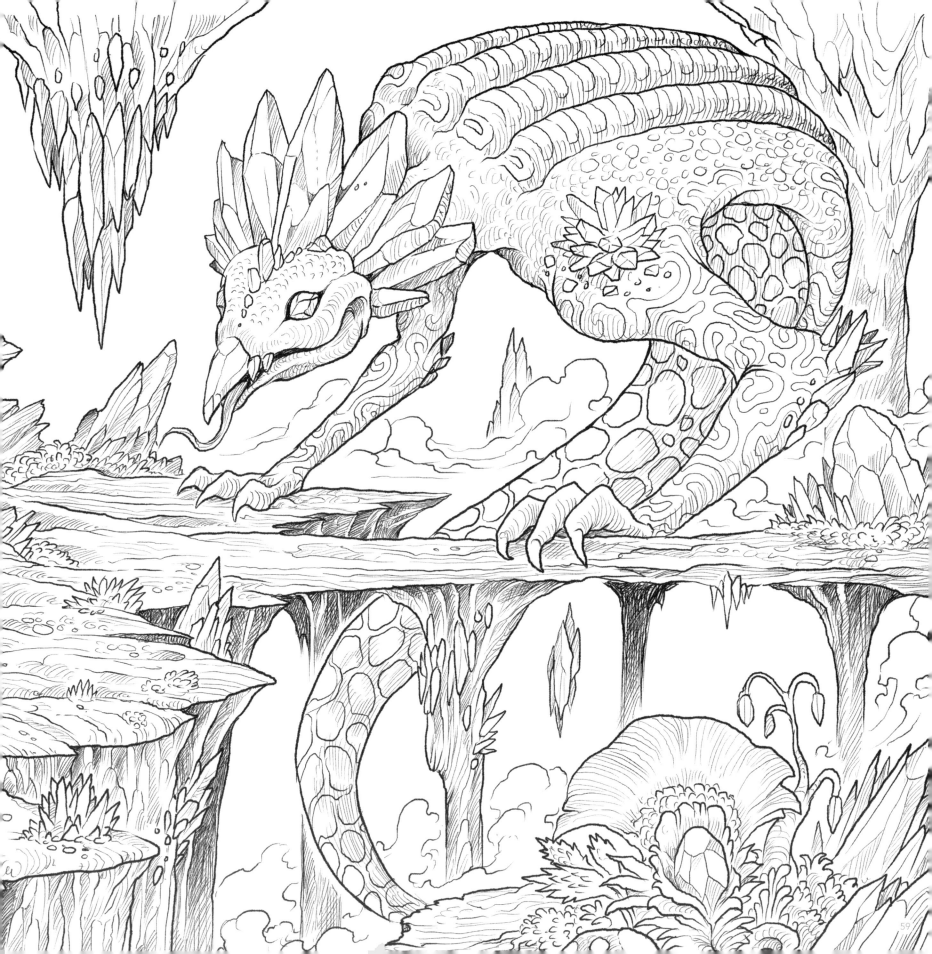

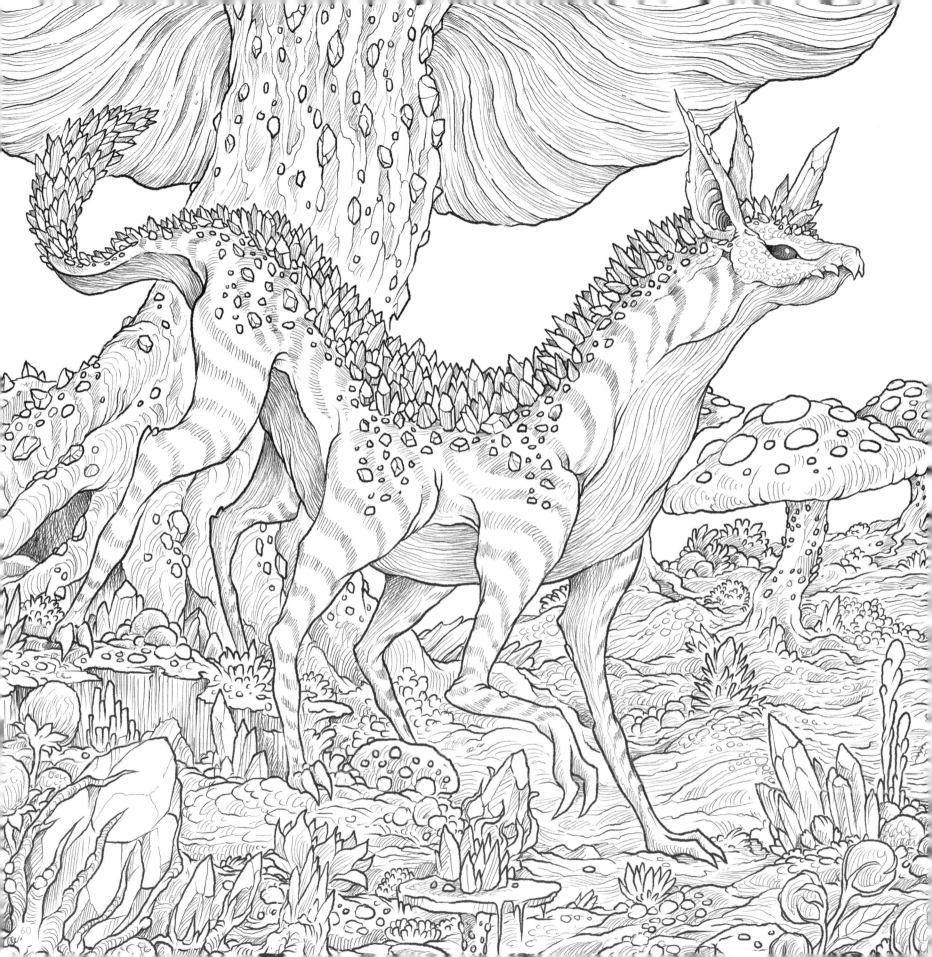

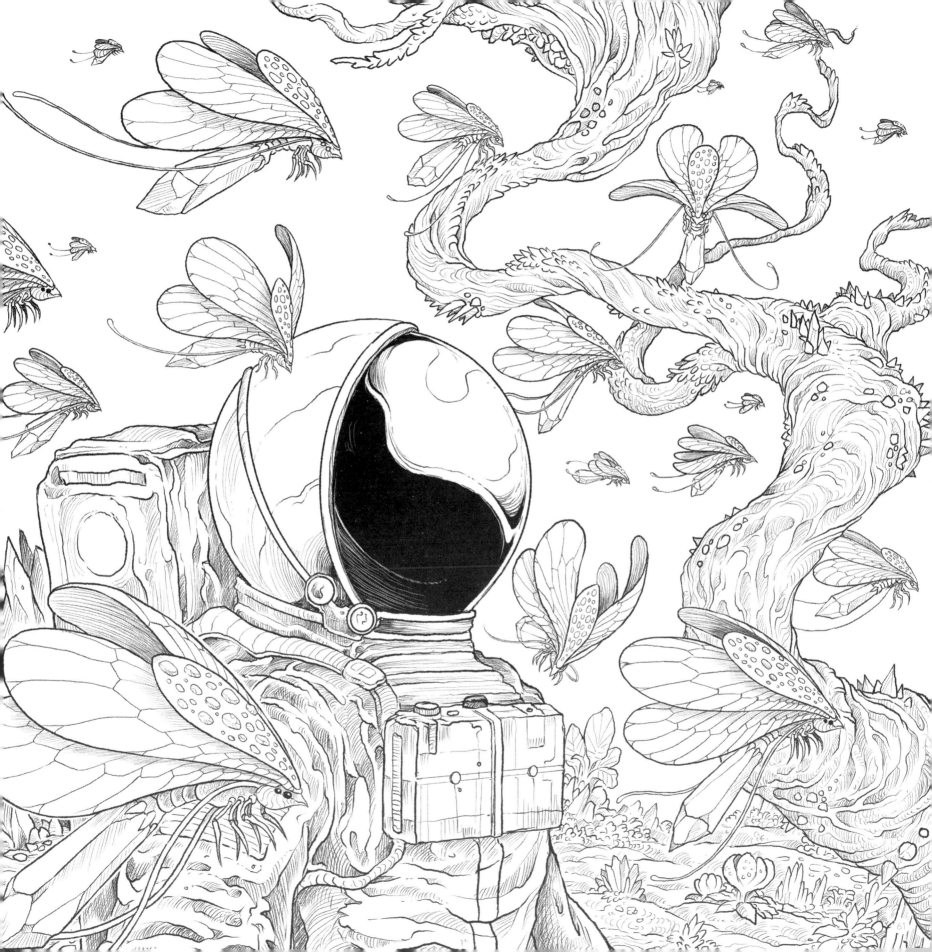

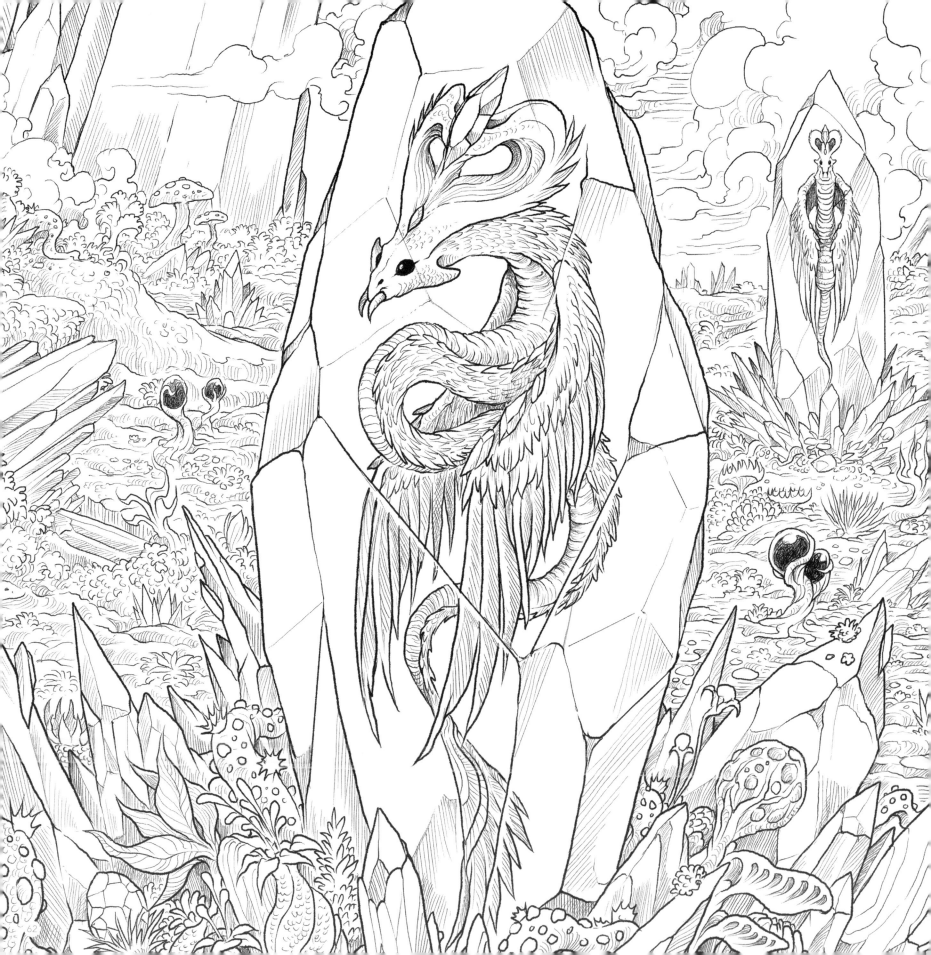

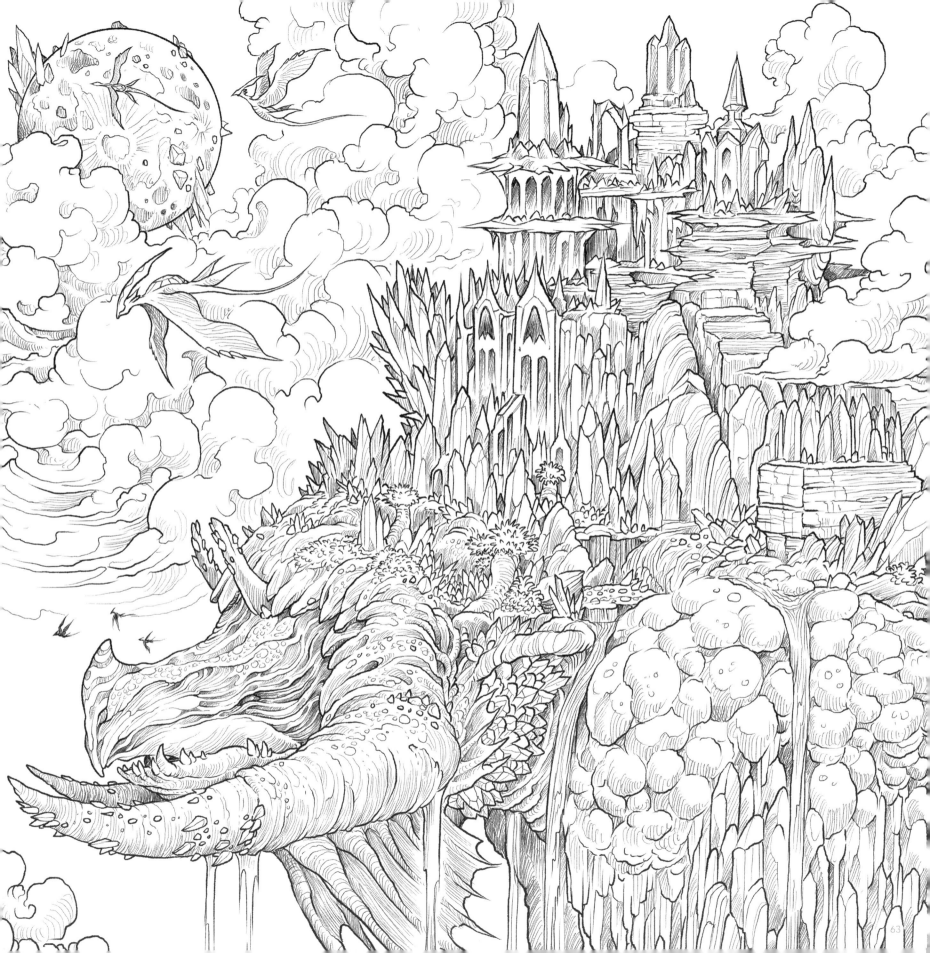

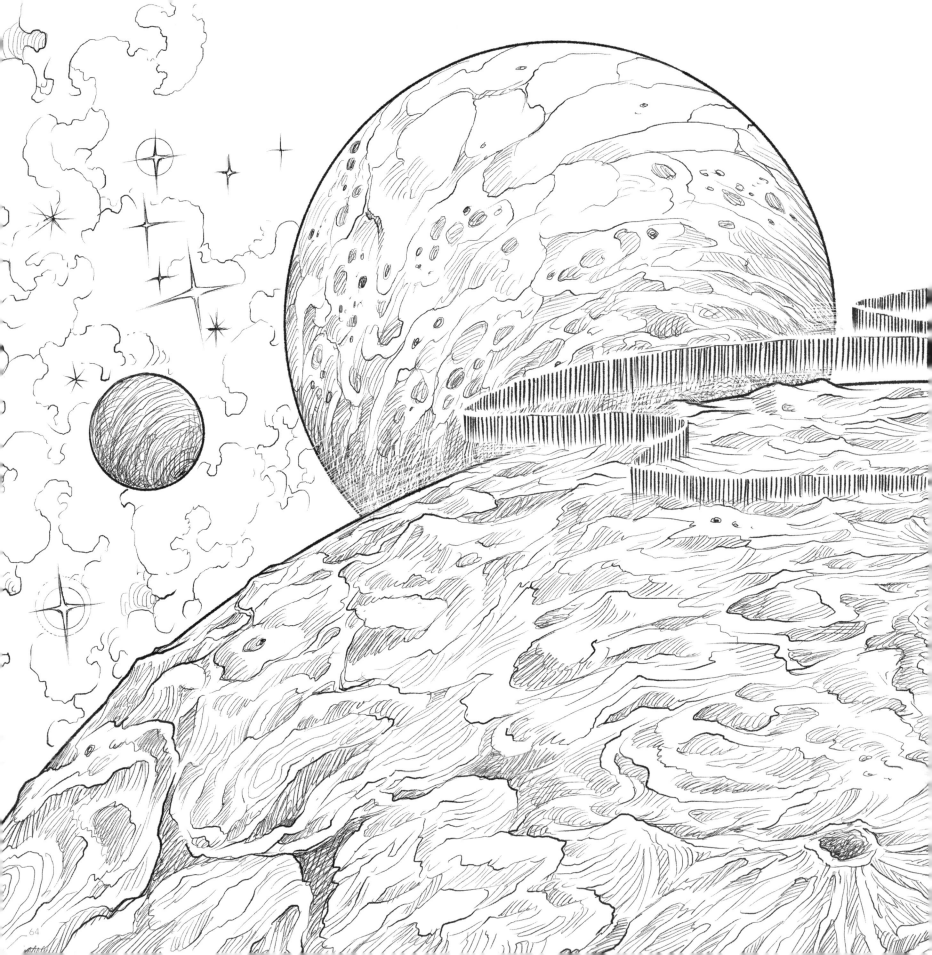

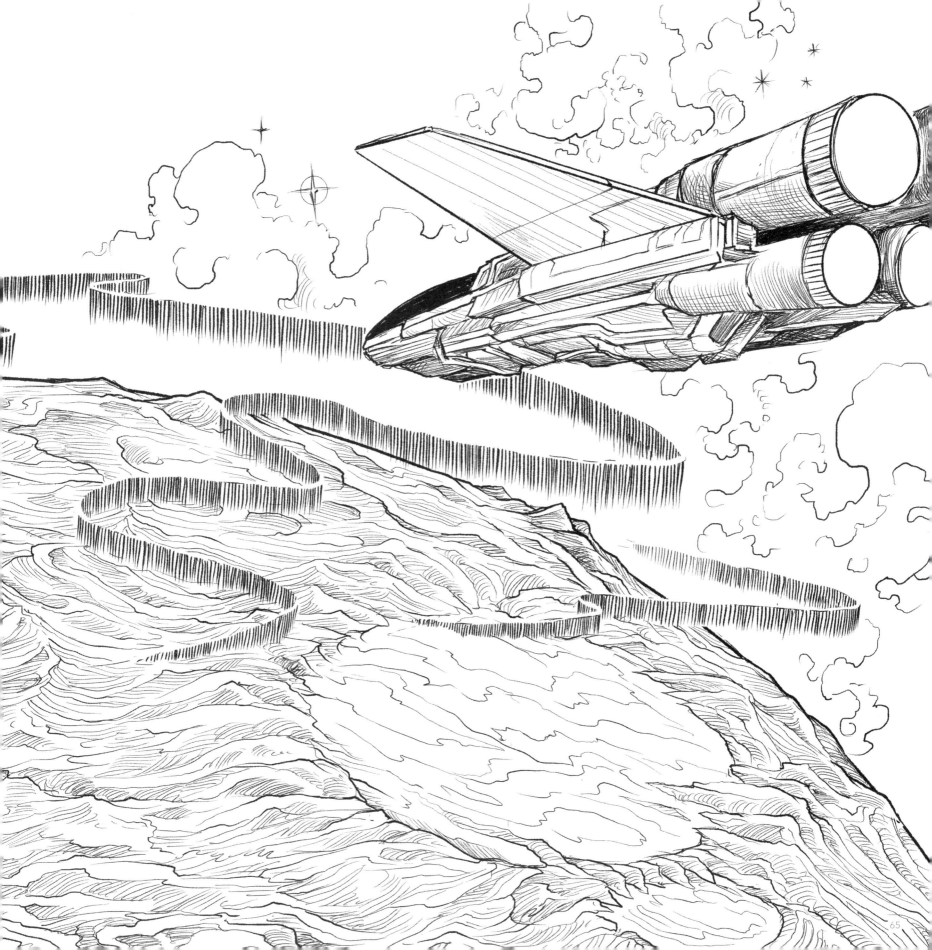

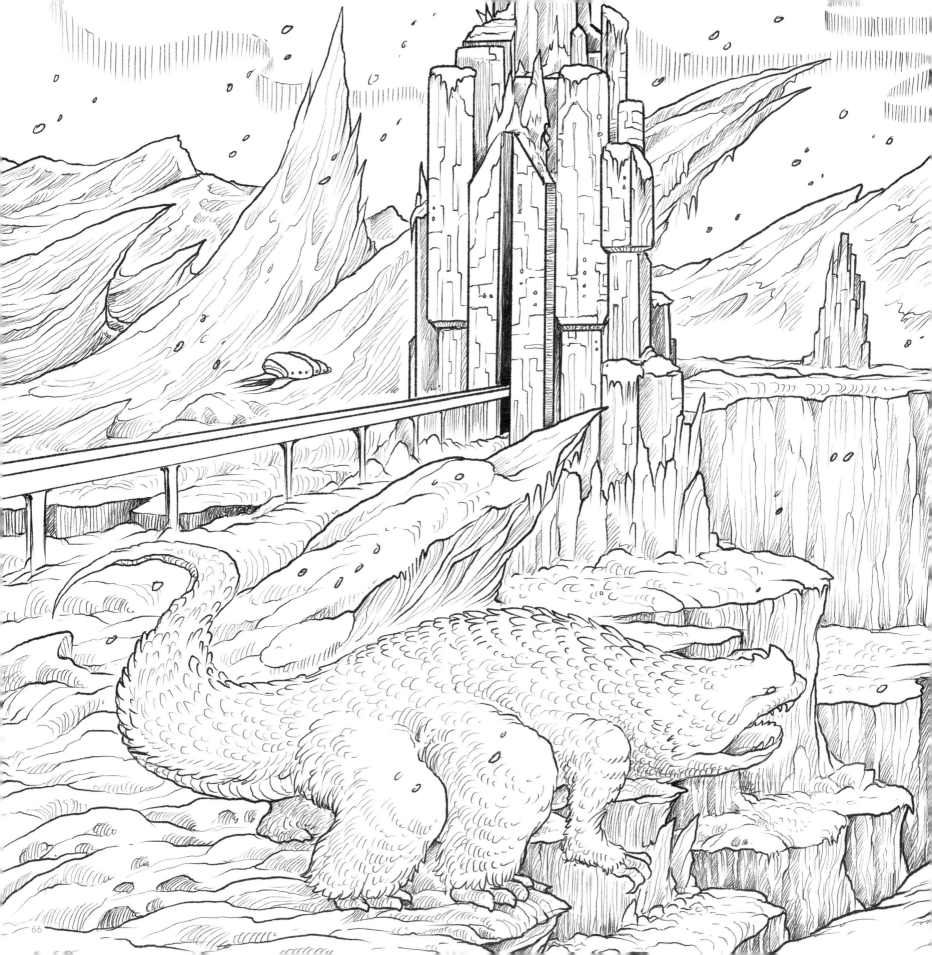

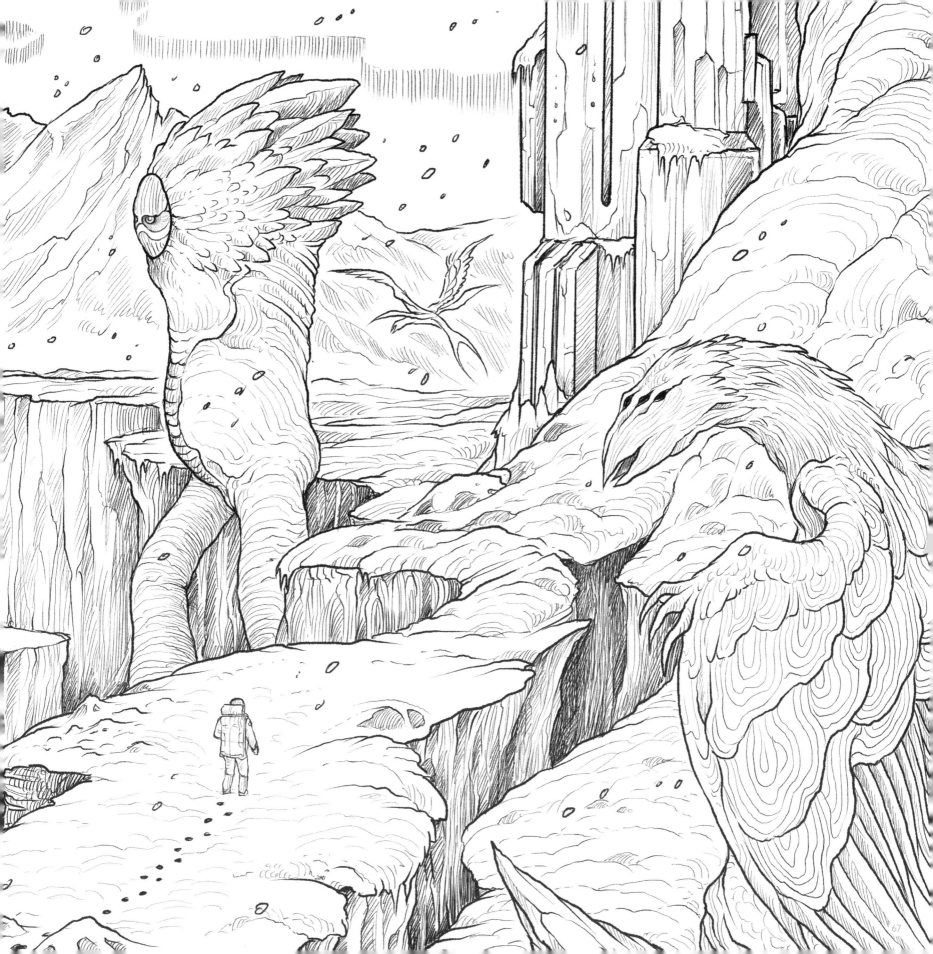

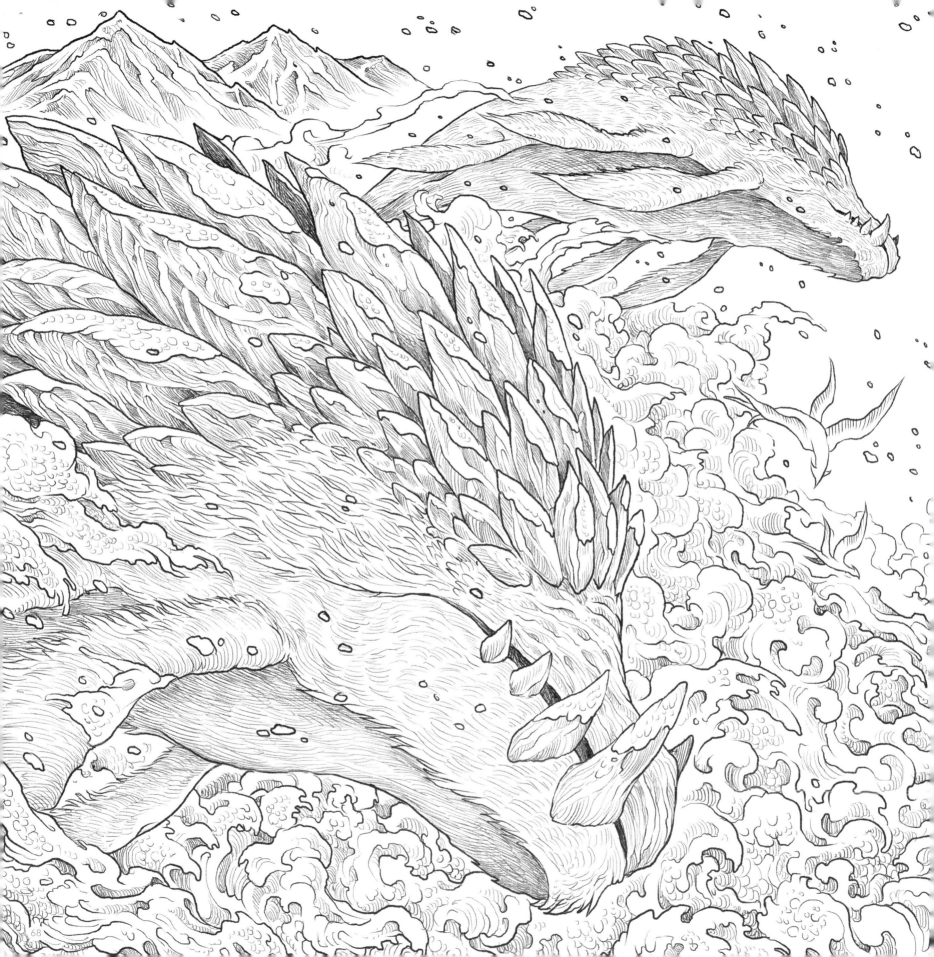

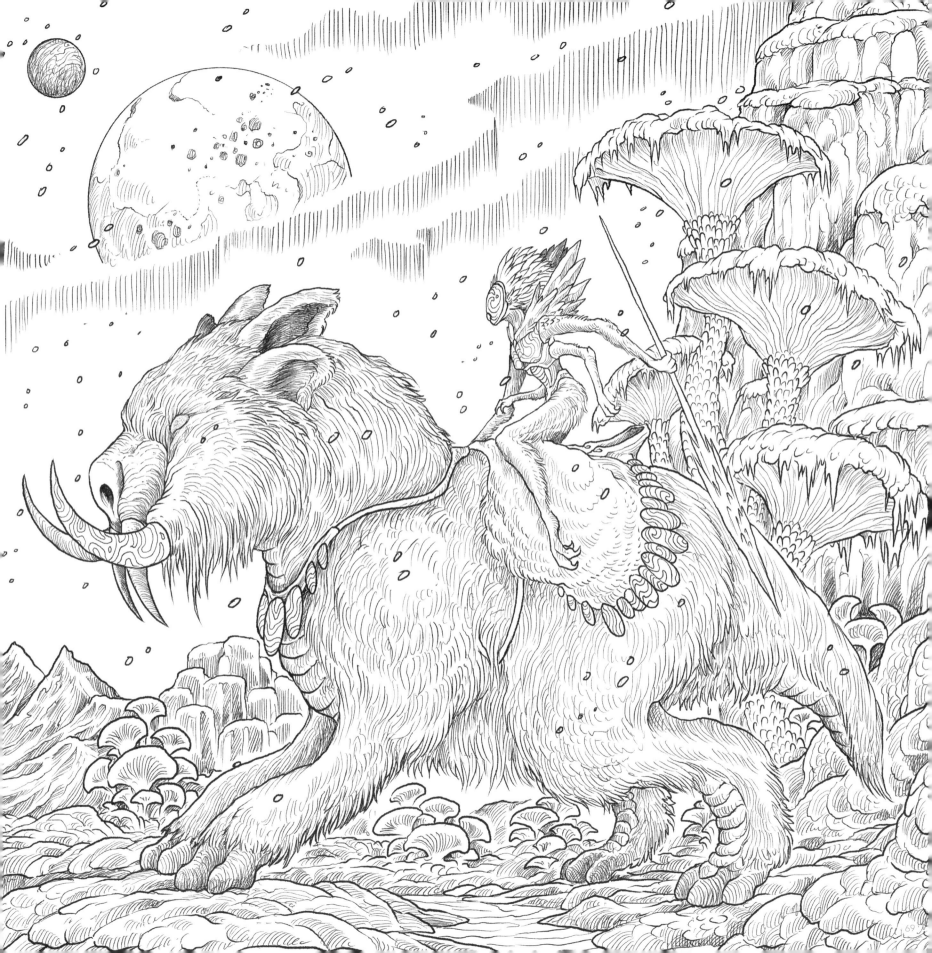

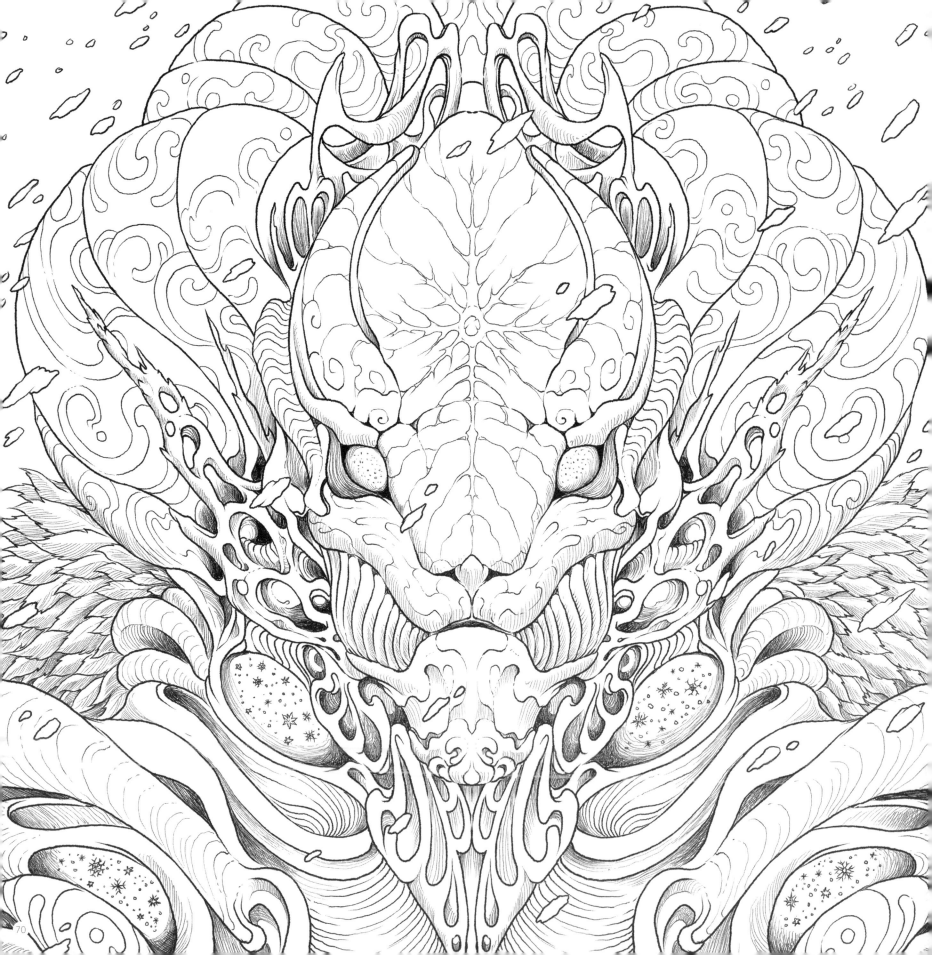

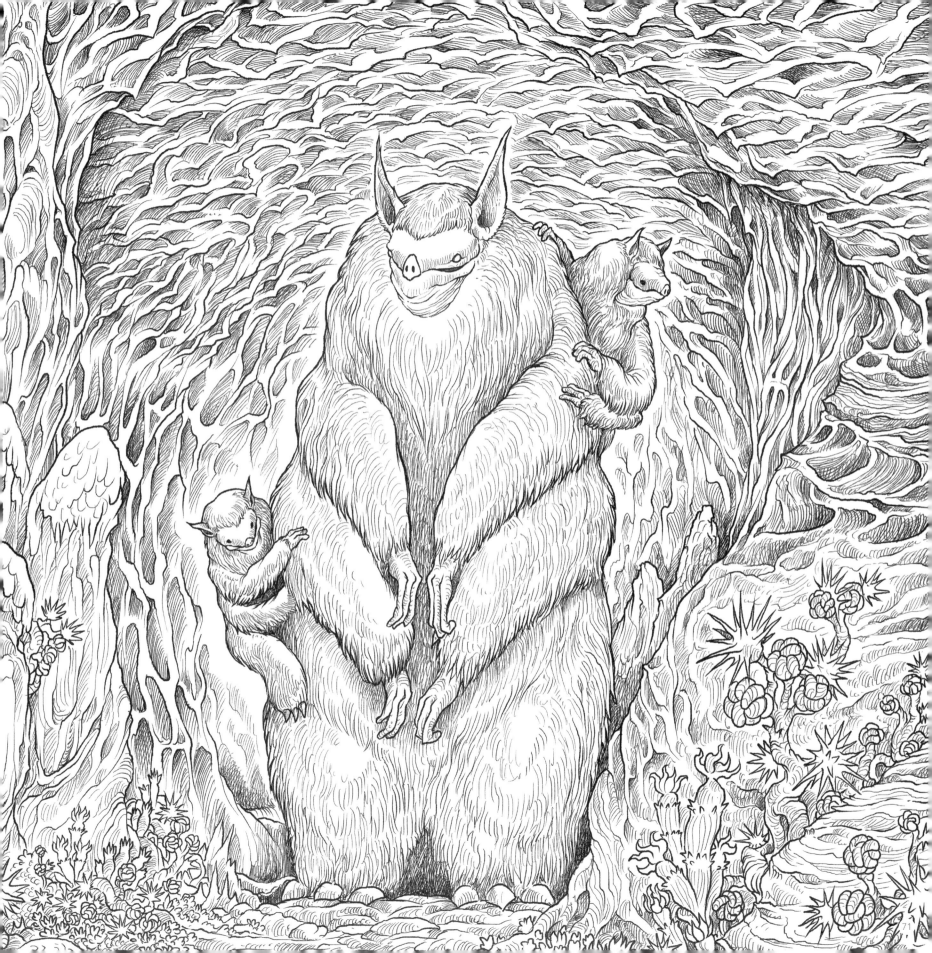

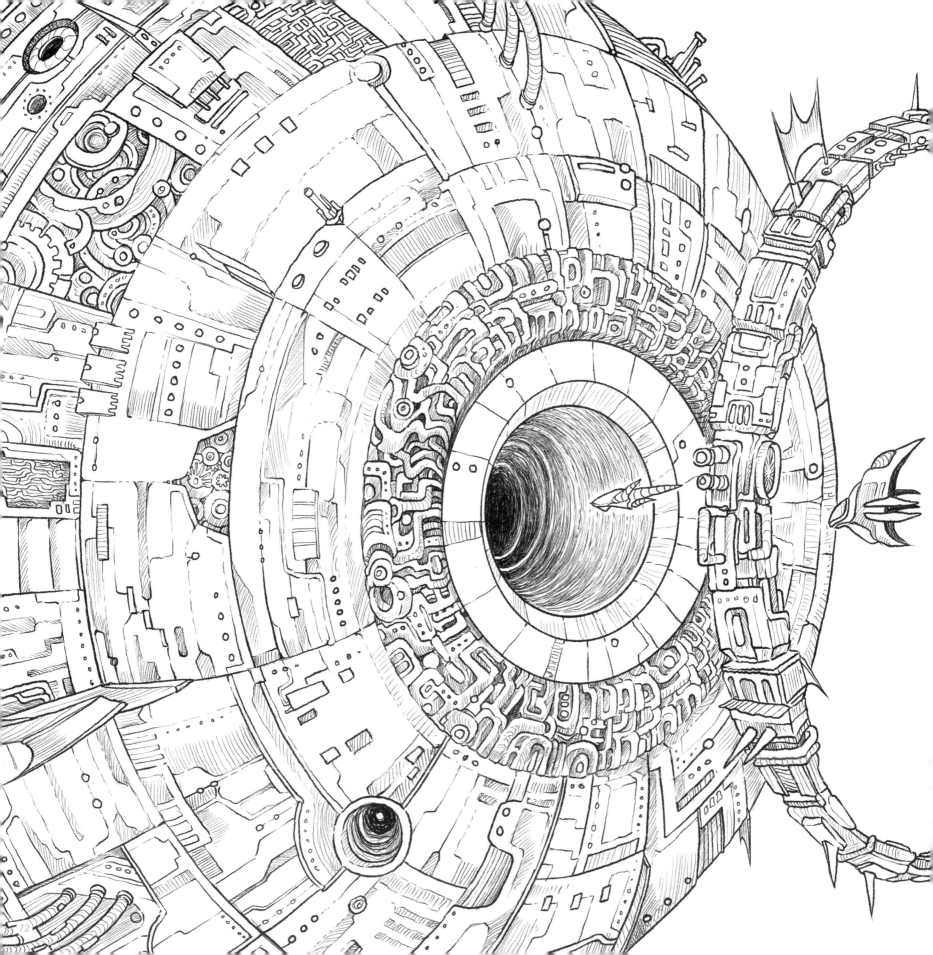

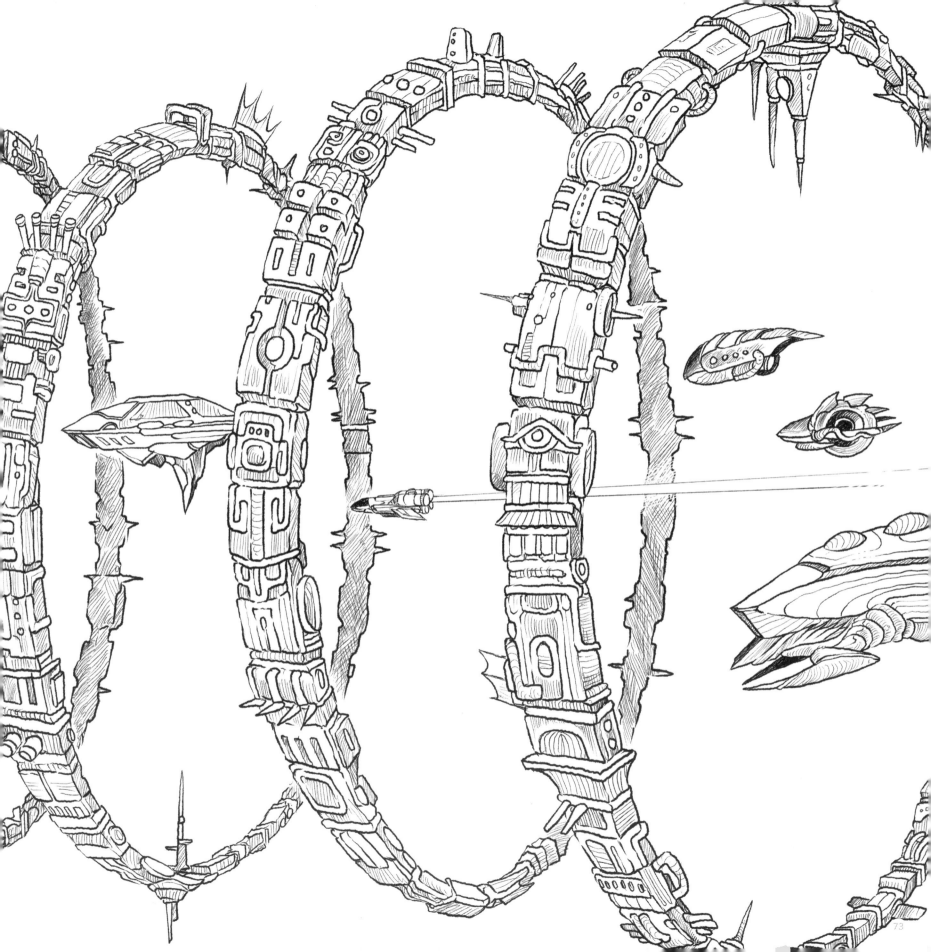

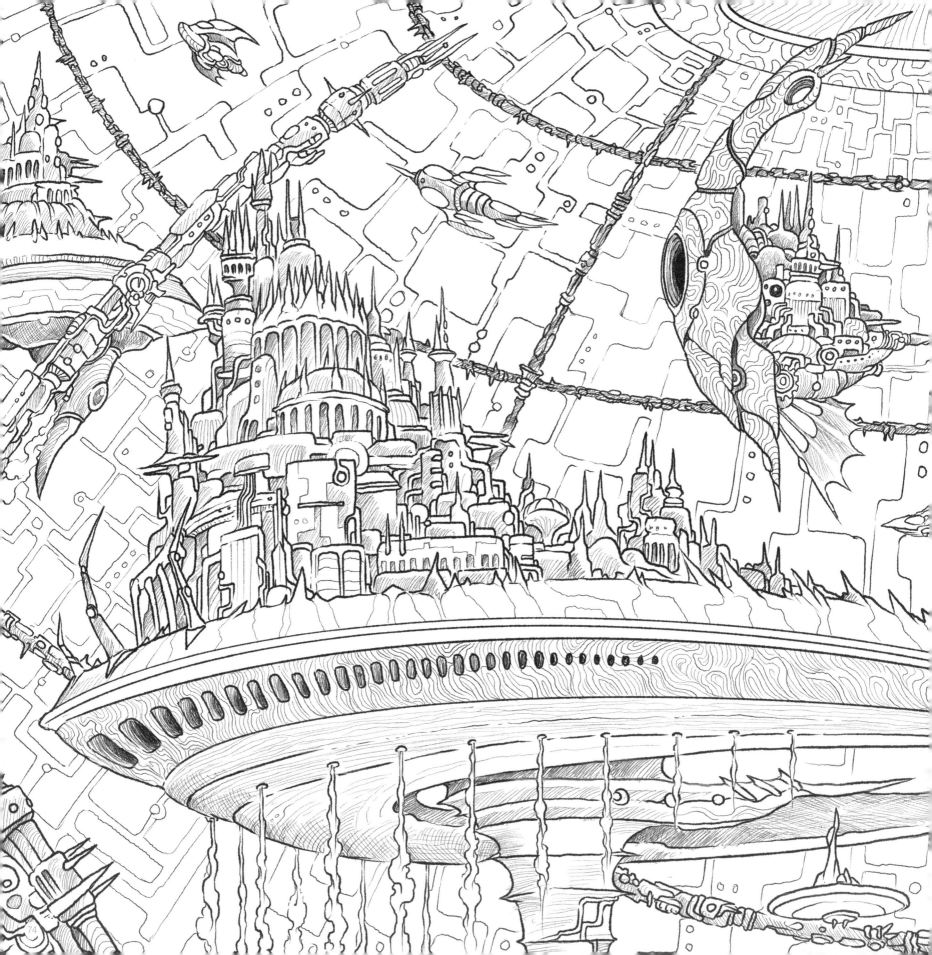

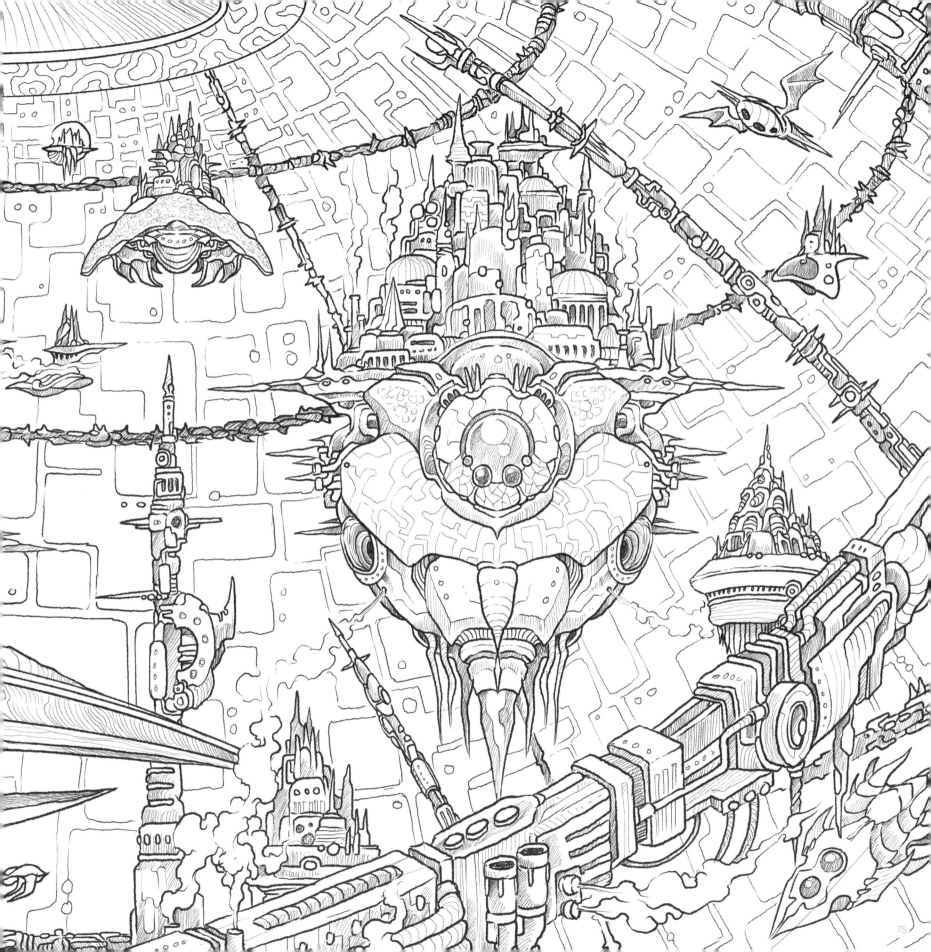

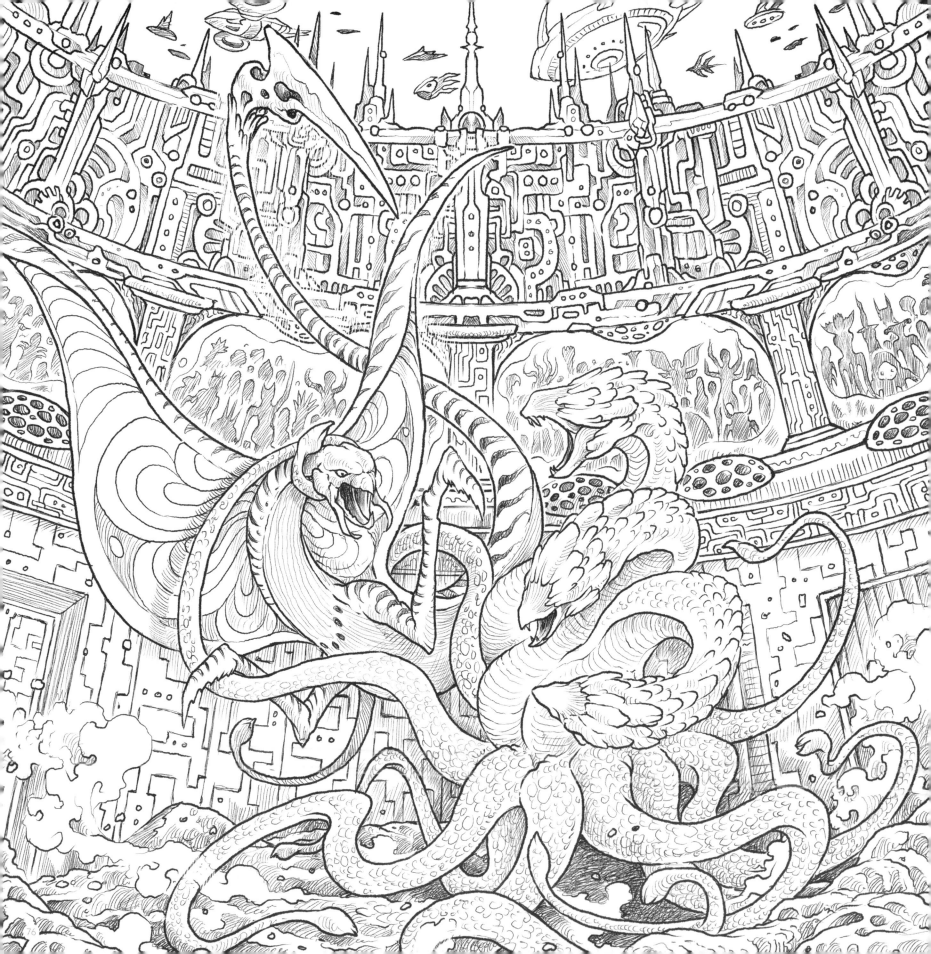

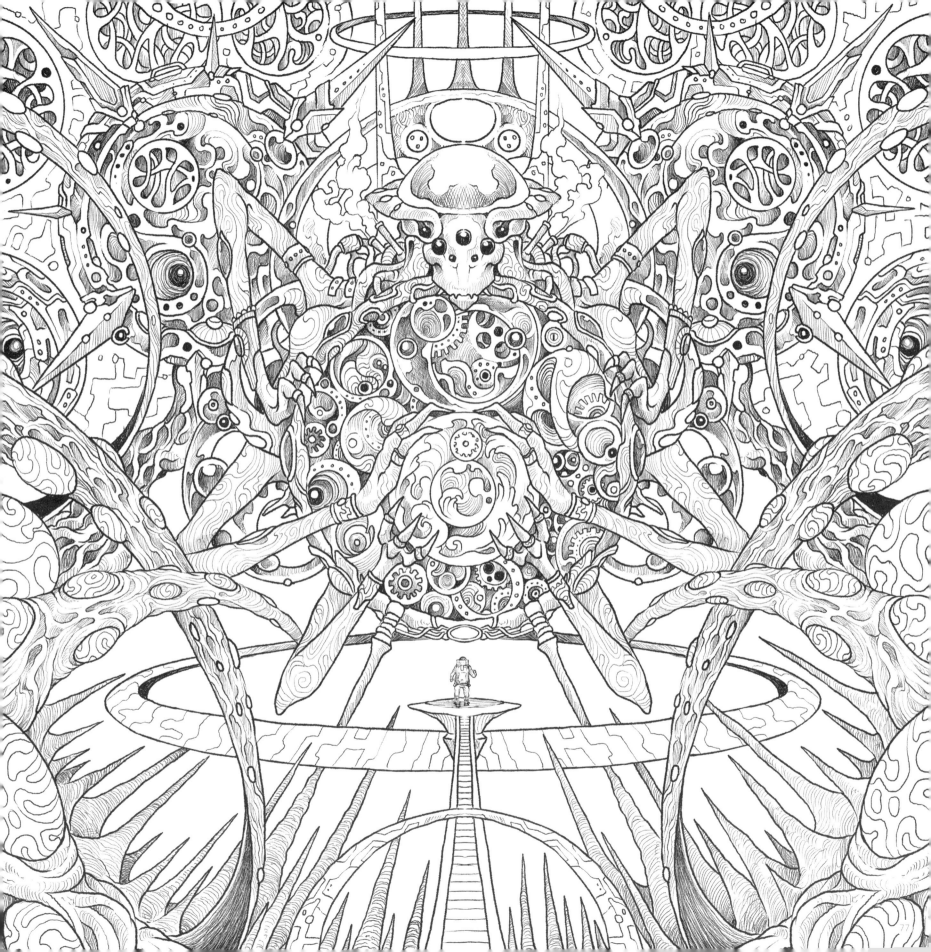

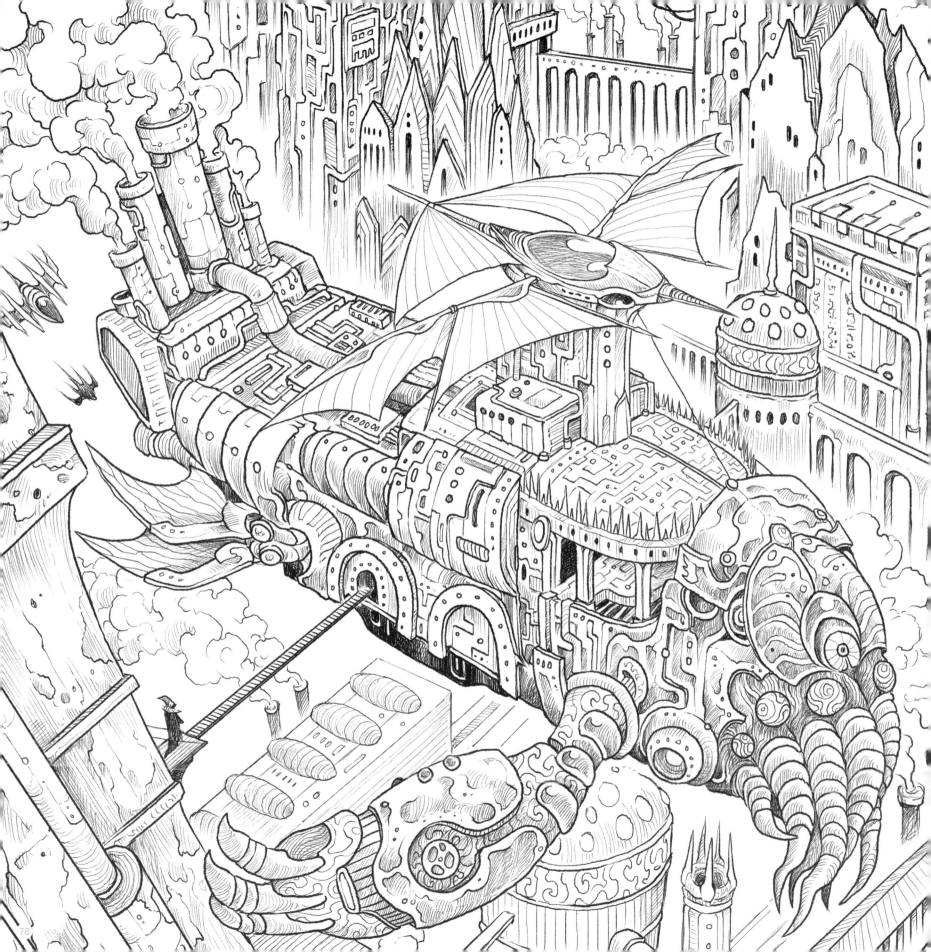

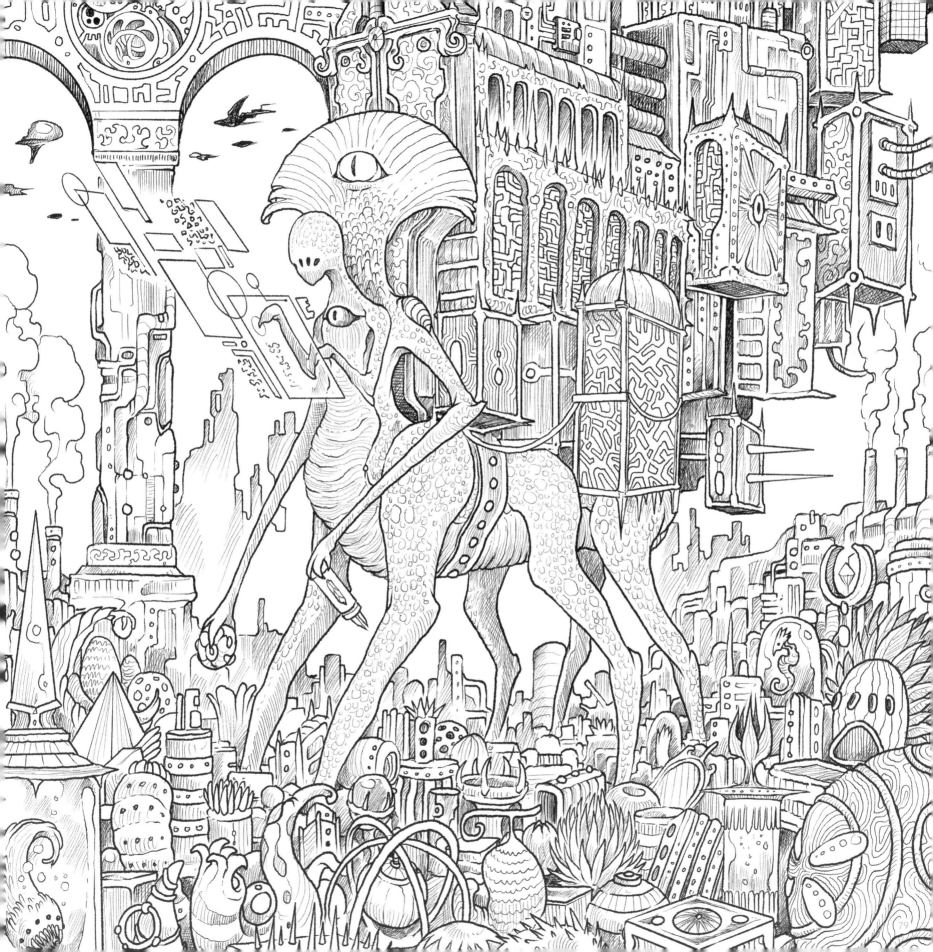

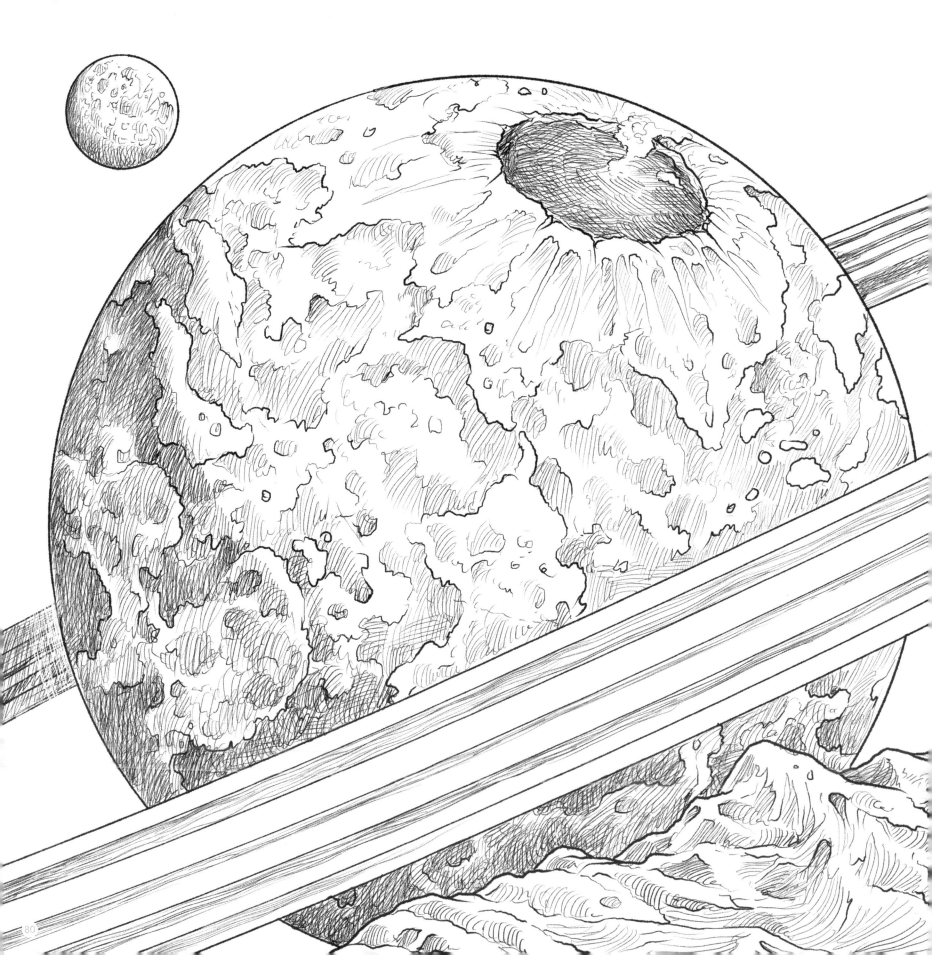

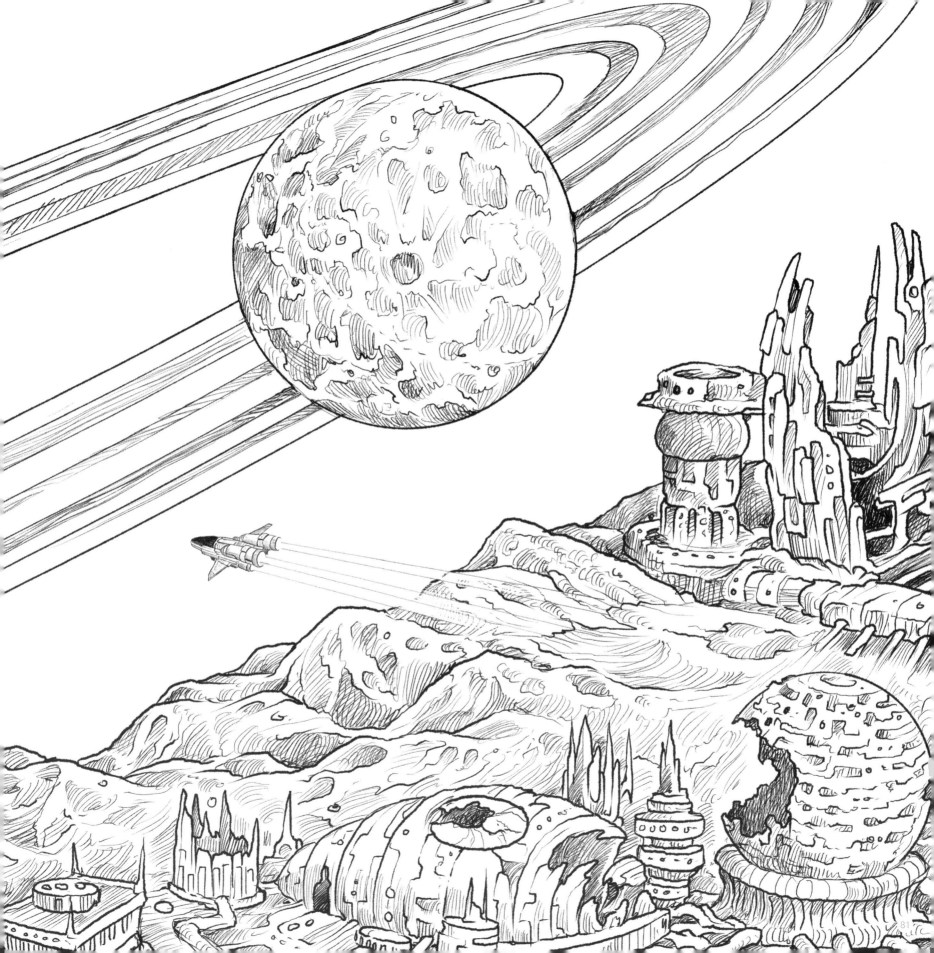

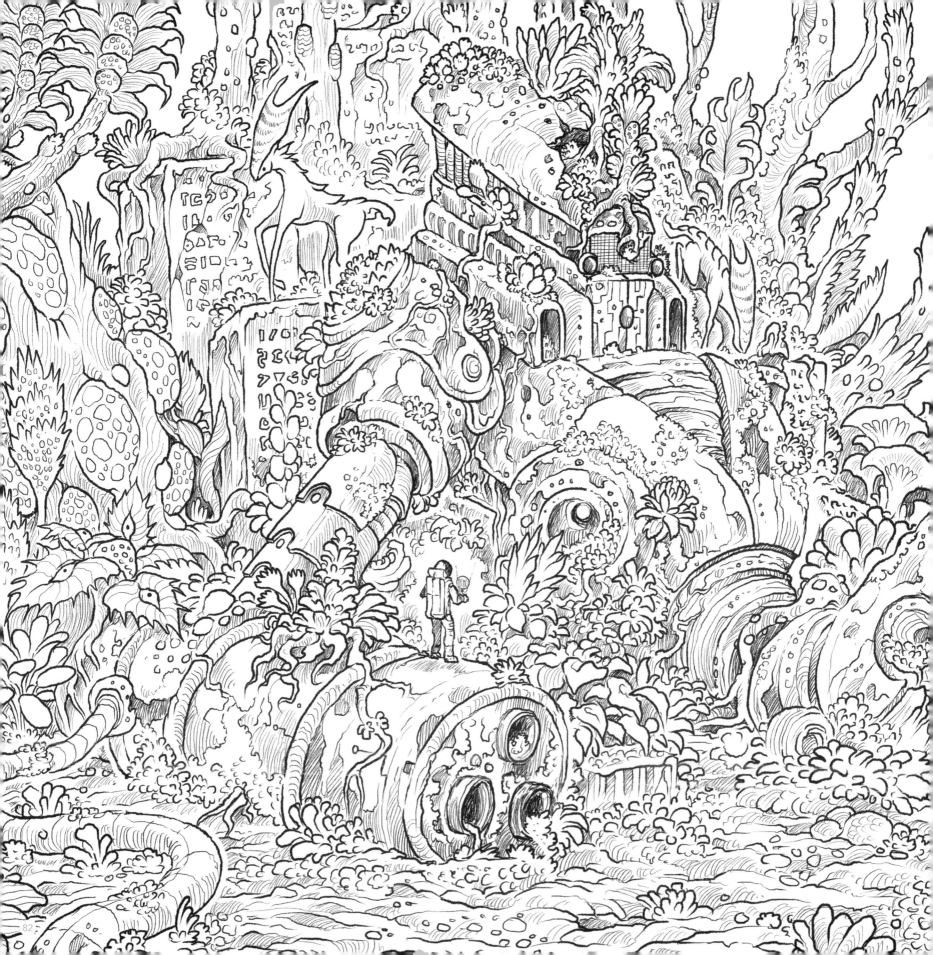

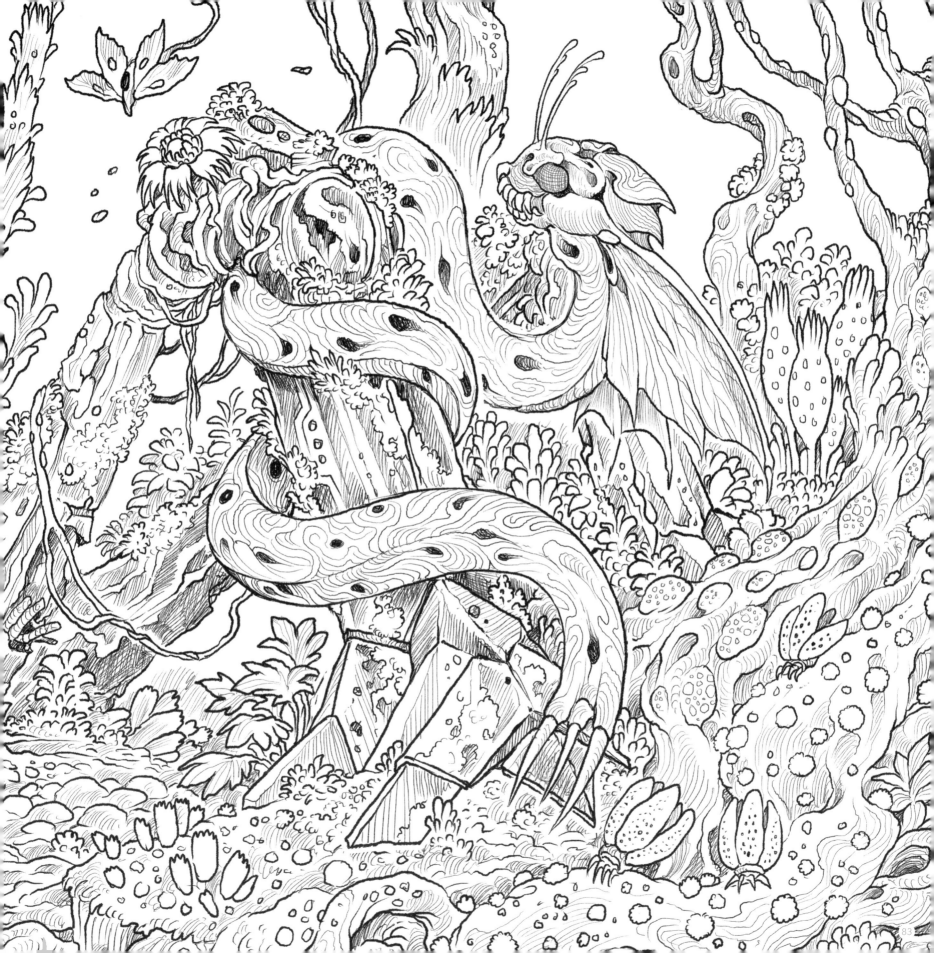

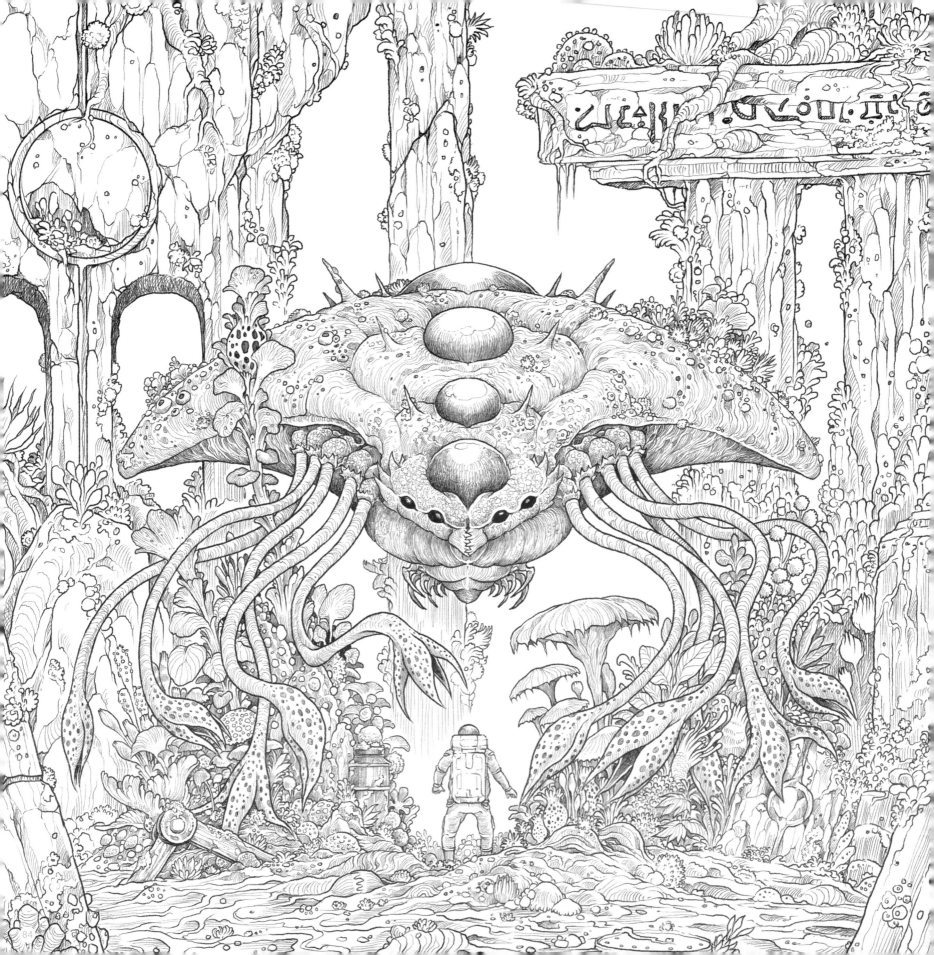

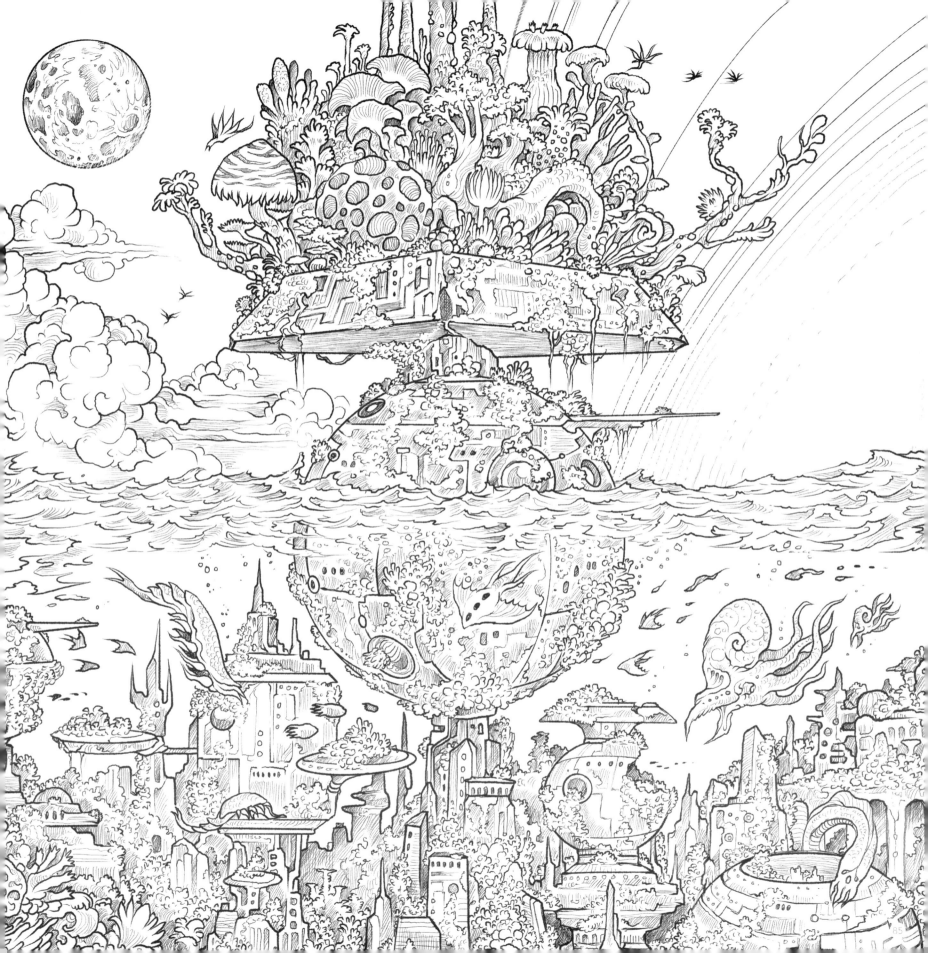

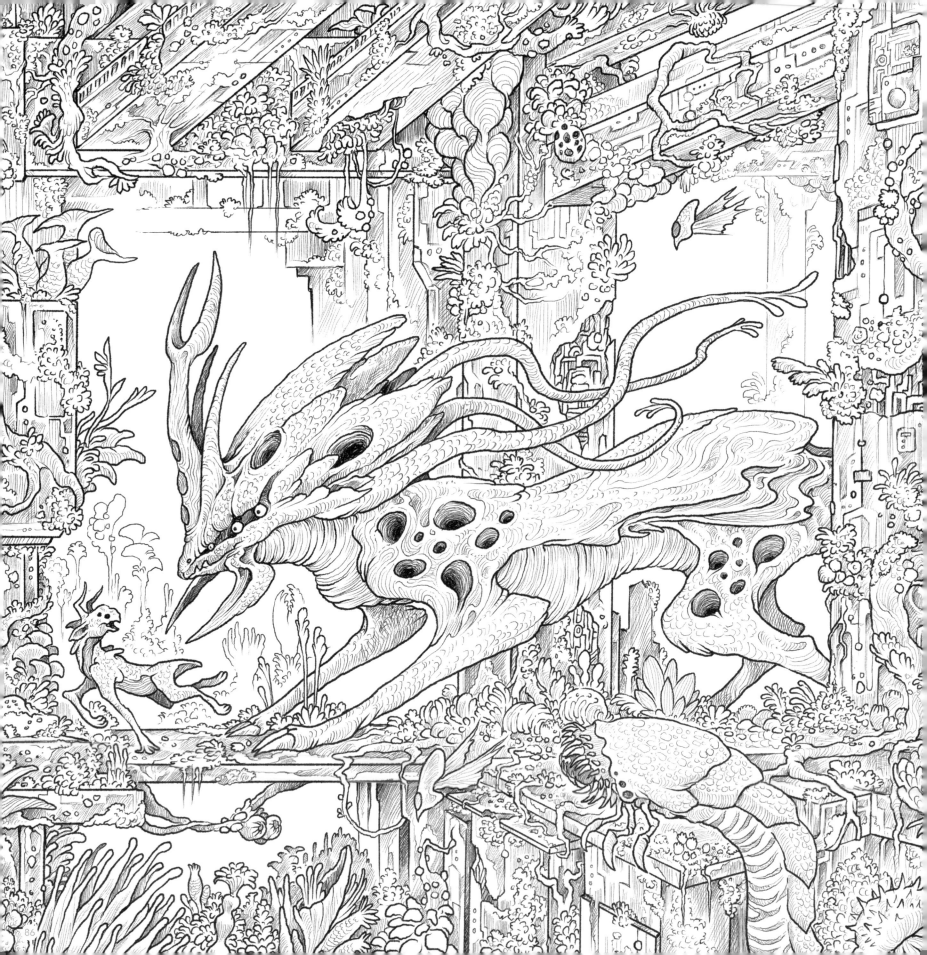

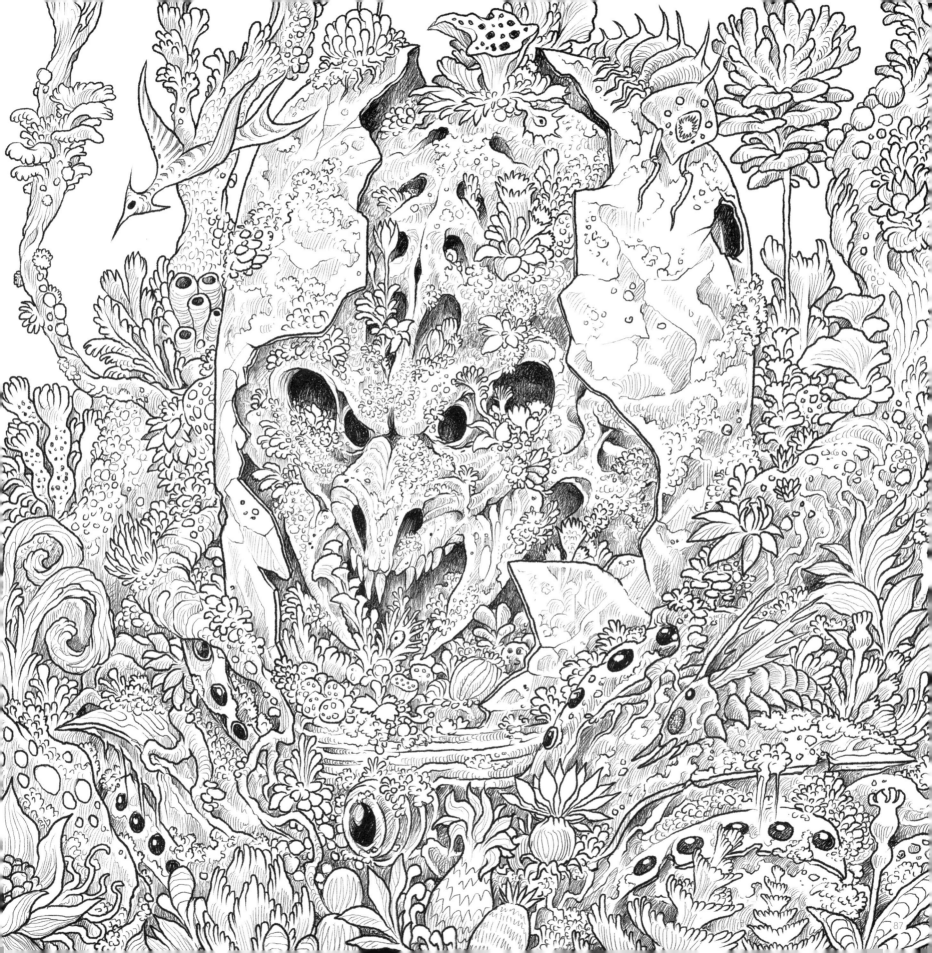

THE ASTRONAUT'S LOG

Find out more about the amazing alien worlds
and awe-inspiring creatures found across the
farthest reaches of the cosmos.

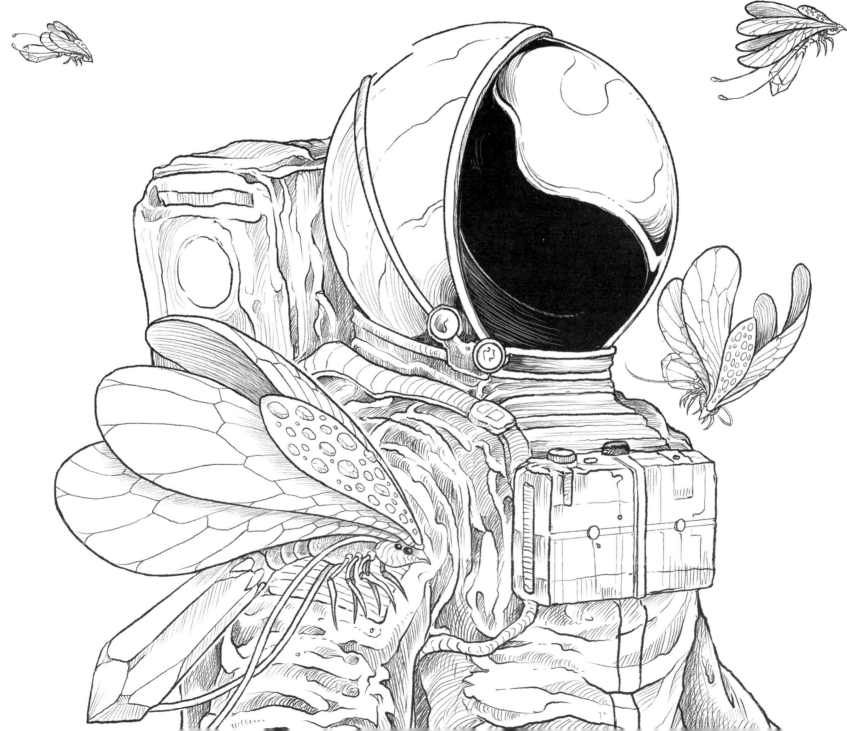

THE LOST PARADISE (PP. 8–9)

Protected by a ring of asteroids and situated in a distant corner of a faraway galaxy, this planet is an unspoiled wilderness. It is covered in dense forests, towering mountains, and fathomless oceans, all so vast that they dwarf those found on our home planet.

LUSCIOUS LANDSCAPE (PP. 10–11)

The surface is teeming with extraordinary life-forms—both flora and fauna. Fungi-like beings litter the ground, providing cover for small creatures. The air—tropical, heavy, and close—is perfect for plant life, and allows herbivores and predators to thrive.

SOLAR-POWERED GIANT (P. 12)

This 20-meter-tall creature is a true gentle giant of an alien. The huge, leaf-like spikes on its back act as solar panels, giving it the energy it needs to clear pathways through the dense landscape in which it lives. It also provides shelter for smaller creatures as it moves.

APEX PREDATOR (P. 13)

With a floral mane for camouflage and five eyes that give it exceptional vision, this leonine predator stalks its forest home in search of prey. It is helped by its long antennae, used to detect subtle vibrations and chemical signatures in the surrounding atmosphere.

FOREST INTELLIGENCE (P. 14)

This stationary, sentient being is rooted to the ground in the center of a sprawling forest. It is thought to be thousands of years old, existing to preserve balance in its environment. Its roots send messages underground; flying plants report to it with information.

FLOWER DWELLERS (P. 15)

Giant plants with luminous patterns hang from the forest canopy and serve as homes for skittish, six-limbed creatures. These winged aliens travel in groups of three, swinging from vine to vine, always on the alert for lurking predators.

THE FLOATING WORLD (PP. 16–17)

Gases, which are so dense they support huge floating islands of rock and stone, cover the surface of this spectacular planet. In contrast to its barren twin, which looms over the horizon, this heavenly body is host to a remarkable variety of sky-dwelling creatures.

NESTING MONSTERS (PP. 18–19)

Gigantic, winged beasts use floating islands, high in the atmosphere, as nesting grounds for their young. The combination of these high-altitude perches and the creatures' epic size—adults can be 150 meters in length—ensures the protection of the next generation.

SPEED DEMONS (P. 20)

The fastest creatures on this planet are magnificent two-headed, six-winged speed demons. They display elaborate, butterfly-like patterns on their wings and are capable of near-continuous flight. They have short forelegs, which are rarely used.

SKY TEMPLES (P. 21)

Beautiful temples, fused to the backs of gigantic armor-plated sky-mollusks gently drift on atmospheric eddies thousands of meters above the floating world's surface. They are used for mysterious rituals performed by an all-knowing alien species.

ROYAL PROTECTOR (P. 22)

Patrolling the skies above the royal castle, a ferocious flying creature keeps this world's ruler safe from attack. It has a strong tail that can knock invaders out of the sky, as well as agile, powerful wings that give it a terrifyingly deadly turn of speed.

ALIEN THRONE (P. 23)

The planet's ruler, resplendent in its finery, spends its life ensconced in the royal palace, found deep within the inner part of this gas planet's thick atmosphere. Here it is shown on its elaborate throne, from which it issues its commands.

THE WATER REALM (PP. 24–25)

This aquatic realm, three times the size of Earth, is entirely covered in roiling oceans and turbulent seas. Four sets of rings—comprised of ice crystals, gas clouds, rocks, and dust—orbit the planet, along with watery moonlets that serve as defensive outposts.

OCEANIC LEVIATHAN (PP. 26–27)

Once the spacecraft has descended through the atmosphere, it is greeted by a leviathan from the deep. This enormous, oceanic alien is flanked by opportunistic scavengers that glide on the salt air, feasting on any morsel of prey it has left behind.

AQUATIC PATROLS (P. 28)

Advanced marine creatures patrol the seas in high-tech hover vessels controlled by their own nervous systems. This symbiotic relationship between scaly sea aliens and modern machines enables them to react to threats almost instantaneously.

WHIRLPOOL TO THE DEEP (P. 29)

Gigantic pillars of bone from ancient marine colossi mark the entrance to a magnificent underwater colony, where this world's advanced life-forms make their home. Churning seas rotate at dizzying speeds, creating a formidable natural barrier to invasion.

SERPENT OF THE SEAS (P. 30)

This enormous, serpentine sea monster lives in the very deepest ocean trenches, where hydrothermal currents from the volcanic seabed sustain a thriving ecosystem. Its streamlined head and body help propel it through the water as it ambushes unsuspecting prey.

THOUSAND-TOOTHED TERROR (P. 31)

No creature can survive the death-dealing maw of this thousand-toothed terror. Once grasped by one of the many sentient tentacles, its prey stands no chance. Its jaw has a powerful crushing force, and its teeth can slice through even the thickest scales.

THE FUTURISTIC PLANET (PP. 32–33)

This highly technologically advanced artificial planet is home to impressive cities, mechanical aliens, and AI-driven life-forms. Its ring systems—connected by light-beam space tunnels—are used for economic activity and planetary defense systems.

SCANNING THE SKYLINE (PP. 34–35)

On the planet's inner ring, the skyline is dotted with space-scrapers reaching up and out through the atmosphere. Colossal spaceships take off and land, hover bots bustle across the surface, and the planetary core looms on the horizon.

PLANETARY POWER CELLS (P. 36)

Millions of power cells are scattered across the planet and its rings, generating the energy needed to run the entire system. They are watched over and maintained by AI hover bots that ensure each fission reaction is kept under strict control.

AI SOLDIER (P. 37)

Highly programmed soldiers are stationed on the outer ring of the planet. These part-machine, part-sentient creatures are all packed into remarkable suits of lightweight tactical armor. They are accompanied at all times by AI-powered drones.

FOUR-LEGGED FURY (P. 38)

Mechanical guard dogs patrol the perimeters of sensitive military outposts. Their jaws can crush metal and their powerful tails can harpoon hover bots, draining them of their energy. They are also some of the fastest-moving creatures on the planet.

SKY CITY (P. 39)

Futuristic cities are scattered across the inner planet. Some have towers that reach up into the atmosphere, others have space ports that reach out toward the stars. All are highly technologically sophisticated hubs of space industry.

THE ROCKY BARRENS (PP. 40–41)

Sometimes the universe throws up planets that seem impossible. The Rocky Barrens, a planet surrounded by pillar-shaped asteroids, is one of those. It is suspended in a giant nebula, buffeted by gas clouds and jostled by space debris.

ROCK MOVERS (PP. 42–43)

The surface of this planet is dry and bare, so most alien species live well below it. However, the snail-like "rock movers" can eke out a living above ground. They weave in and out of the giant thermal pillars that channel energy to the cities below.

FEROCIOUS FLOWERS (P. 44)

Some aliens on this planet look like innocent flora, but they are actually deadly predators. This fierce creature mimics the appearance of a plant but uses its sweet scent to attract small animals and its giant petal-head full of razor-sharp teeth to devour them.

BATTLE-SCARRED COLOSSUS (P. 45)

Creatures on the surface must be hardy to survive, and none are as tough as this epic monster. The solid ball of rock on the end of its tail is used in contests with others of its type. For the losing combatant, it usually means death.

GOING UNDERGROUND (P. 46)

The planet's most advanced civilization has developed underground. Intricate cities gouged out of rock are supplied by insect-like spaceships. These craft make frequent sorties to the world above or through the labyrinthine cave systems that lie even farther below.

UNDERGROUND INCUBATOR (P. 47)

Just below the surface, an oversized, insect-like alien guards her eggs; she is capable of laying thousands at a time. However, once hatched, the young are on their own. The vicious hatchlings are prone to cannibalism if they are unable to find sufficient food.

THE HEAVENLY INFERNO (PP. 48–49)

This planet has strayed too close to its parent star. Once fertile and lush, it is now a raging hellfire. However, lava flows, volcanic activity, poisonous skies, and scorching temperatures haven't stopped ferocious life-forms from making this world their home.

LAKES OF FIRE (PP. 50–51)

The surface of the planet is pockmarked with lava-spewing geysers, perfect for the monsters that have adapted to its hellish conditions. The stench of sulphur fills the air and the planet's disintegrating moon hangs in the sky, foretelling its own ultimate fate.

LAVA WORM (P. 52)

The lava worm is a nightmarish creature that lurks in the depths of the magma caverns that dot this world. It emerges from molten lava lakes to startle unsuspecting prey. Tentacles protrude from its hellish mouth, which is studded with a ring of jagged fangs.

VOLCANIC BEAST (P. 53)

The reek of sulphur radiates off this volcanic beast. Its huge, rocky arms belch out clouds of fiery lava and toxic gases whenever it feels threatened. It spends most of its life at the foot of volcanoes, basking in their heat. Its violent roar can cause earth tremors.

FLAME BUG (P. 54)

This tiny insect packs a serious punch. Whenever it is agitated or under threat, its entire body emits fire, which its powerful wings can propel through the air like a flamethrower. It is found in underground cave systems, and it feeds on the remains of dead creatures.

METEOR MYTHOLOGY (P. 55)

This legendary alien only appears during meteor showers. It is so rare that it was once believed to be a mere myth. It has a flaming mane of fire, powerful claws that can slice through rock, and "fire blades" on its forelegs that can scorch any enemy or prey.

THE CRYSTAL KINGDOM (PP. 56–57)

At the center of an intergalactic tunnel of glittering cosmic geodes, a crystal planet glows like a sun. The most stunning alien world among a whole star system of crystalline planets, the Crystal Kingdom is a bright jewel in the blackness of space.

A GLITTERING LANDSCAPE (PP. 58–59)

The plants and trees that form this crystal world's landscape are covered in precious jewels. Shimmering aliens, which appear in both animal and mineral forms, meander through gemstone-strewn canyons complete with giant crystal pillars and glittering rock formations.

JEWELED CREATURE (P. 60)

Unusual beasts roam the crystal landscapes. This six-legged herbivore treads lightly across the jeweled ground to avoid detection by larger predators. The colorful jewels on its back attract mates, and the number of crystals on its body denotes how old it is.

WORLDS EXPLORER (P. 61)

Insects with wings patterned like stained glass and jeweled abdomens that glow at night flutter among the planet's flora. It makes for an enchanting, otherworldly experience even for the most well-traveled astronaut.

CRYSTAL HIBERNATION (P. 62)

Mysterious flying creatures spend this world's harsh winters hibernating. When the year's first cool winds begin to blow, they expel a special gas around themselves, which hardens and turns to crystal. In spring, they stretch their wings and break free.

CREEPING CASTLES (P. 63)

A lumbering beast, which can live for millions of years, provides a home for this planet's civilization. The majority of the population lives in the majestic cities carved into the beast's gigantic crystal shell, with the elite living in the impenetrable castles towering above.

THE FROZEN WASTES (PP. 64–65)

Glittering like an icy gemstone in a far-off galaxy, this frosty, snow-covered planet is a truly freezing world. It is blanketed in snow and ice all year round, and accompanied by a frozen moon orbiting high above the colorful aurora that dances in its skies.

ALIEN ODDITIES (PP. 66–67)

Strange beasts have evolved to cope with this planet's freezing temperatures. Burrowing snow creatures, crevice-dwelling oddities, and winged monsters all skirt the margins of the planet's small civilization, which clings to existence in fortified strongholds.

SNOW-SURFING COLOSSI (P. 68)

With their graceful and powerful bodies propelling them through snowdrifts, and strong fins that help them leap into the air, these majestic alien creatures resemble Earth's whales and dolphins. Their rocky spikes give them a more ferocious appearance.

ICE HUNTERS (P. 69)

This planet's inhabitants have to be inventive and innovative to survive. This four-armed hunter travels on the back of the fastest land animal in the frozen wastes. Its powerful sense of smell can detect prey that lives far below the snowy surface.

COLD BEAUTY (P. 70)

This intelligent being's face resembles a lion crossed with a giant insect. It wears ice-crystal jewelry on its head and precious frozen gems on its neck. A cape made from a snow bird's feathers is worn draped around its shoulders, indicating its noble status.

FRIENDLY FACES (P. 71)

Not all alien life-forms on this planet are fierce. These furry, cave-dwelling creatures live peaceful lives, scavenging for small fruits, nuts, and seeds that can be found in shady places. Their dense coats keep them well protected from the cold.

THE STEAMPUNK SPHERE (PP. 72–73)

This colossal planetary megastructure is home to a highly advanced civilization that plays host to numerous alien species from different planets and galaxies. It is protected by several defensive security rings.

GALACTIC CITIES (PP. 74–75)

The gigantic dome is full of enormous floating cities, each with a different galactic origin, culture, and leadership. Some are the last outposts of their respective worlds. The cities work together as one to maintain order and peaceful coexistence.

ALIEN GLADIATORS (P. 76)

One of the most popular attractions in the Steampunk Sphere is the colosseum, where the strongest creatures from across the cosmos fight with one another to become the galactic champion. Vast crowds gather to soak up the action and cheer on their favorites.

THE TIMEKEEPER (P. 77)

No one knows for sure how this planetary mechanism was formed, but the answer probably lies with the Timekeeper. A sentient mechanical creature that lives in the center of the world, this being holds the answers to many questions, but never tells . . .

SOLAR AIRSHIP (P. 78)

The planet is open to anyone in the galaxy, including traders, travelers, and alien tourists. Vast airships ferry them around the interior, using wind and steam power to sail through the air. Docking points are dotted around the planet for their convenience.

TRADING TREASURES (P. 79)

Given its status as a galactic meeting point and trading hub, the Steampunk Sphere's civilization has amassed a vast treasure trove of ancient artifacts, from rare antiques and weaponry to curios and trinkets. This vast collection must be regularly catalogued and sorted.

THE DESOLATE RUIN (PP. 80–81)

Not all civilizations stand the test of time. This planet's was destroyed when a giant asteroid slammed into its northern hemisphere. Millions of years after the devastation, new life-forms have begun to emerge, making their homes among the ruins.

ROBOTIC WRECKAGE (PP. 82–83)

The planet's surface is now teeming with life. New plant species and alien animals abound. Giant mechanical beings from the previous civilization have ossified and now provide cover for new ecosystems to flourish.

PERFECT PREDATOR (P. 84)

A gigantic, insect-like alien lurks in the remains of a long-since-abandoned temple complex. Its tendril-like tentacles are used to propel it forward and ensnare its prey. It normally eats smaller aliens and grubs, but it'll happily eat anything that crosses its path.

SUBMERGED SEA CITY (P. 85)

A deep-sea city once flourished among the myriad oceangoing aliens that filled this planet's waters. Now just a rusting ruin, the city still plays host to a wide variety of life-forms. They have to be hardy to survive seas long ago polluted with radioactive material.

LURKING IN ITS LAIR (P. 86)

Ancient loading docks for spacecraft are now home to some of this planet's most dangerous animals. This alien has a two-pronged horn it uses in battle with others of its kind, sharp hooves for mauling prey, and terrifying protruding mandibles for slicing flesh.

END OF WORLDS (P. 87)

Even the most intelligent creatures have to face their doom in the end. The skull of this alien, encased in a cracked visor and surrounded by weeds, is one of the few physical remains left of this species. Only its precious jewels have withstood the passage of time.